TOM ATWOOD

KINGS & QUEENS IN THEIR CASTLES

DAMIANI

ARTIST'S STATEMENT

Kings & Queens in Their Castles is an extensive photography series exploring the LGBTQ experience in the USA. Over 15 years, I photographed more than 350 subjects at home nationwide (with over 160 in the book), including nearly 100 luminaries (with about 60 in the book). With individuals from 30 states, the series offers a window into the lives and homes of some of America's most intriguing and eccentric personalities.

The title, in addition to paying tribute to our dazzling drag kings and queens, is a nod to aristocracy from history reputed to have engaged in alternative sexuality or gender practices or sensibilities. Among these are Japanese samurai knights, Roman emperor Hadrian, French kings Henri III and Louis XIII, Alexander the Great, England's King Edward II, King James I of England and Scotland, Queen Christina of Sweden, Prince Eugene of Savoy and King Ludwig II of Bavaria. Not to mention King Frederick II of Prussia, with his Sanssouci palace adorned with gay-themed antiques.

I decided to photograph LGBTQ Americans because I felt there was a need for a contemplative photo series of the community. Many LGBTQ series depict scantily-clothed young subjects romping through the forest or lounging on the beach. There was a need for a series highlighting our manifold personalities and backgrounds. And I wanted to create a body of work that would strengthen the identity of and be a source of pride for the LGBTQ community, as well as feature role models.

Today, in terms of the modern civil rights movement, it's helpful to highlight that LGBTQ folks are in many ways like everyone else, and as diverse as society as a whole. Yet on another level, there is a common LGBTQ sensibility that sets us apart that I wanted to recognize and celebrate. This sensibility shares an outlook with the sensibility of creative and cultural leaders—an awareness of difference, of other, of possibility—an avant-garde mindset. One fascinating phenomenon my series explores is just how many creative and cultural leaders are LGBTQ. We may be disproportionately represented in the arts, culture and entertainment.

This seems as true now as it may have been throughout history. Homosexuality or a gay sensibility appears in art from virtually every culture and time period—from ancient Peruvian ceramics to nearly all Greek art forms to fourteenth century Japanese art. Moreover, examples of LGBTQ individuals excelling in art and culture abound. From Native American berdaches, with their exceptional aptitude for crafts, to da Vinci, Michelangelo, Cadmus, Warhol, Rauschenberg and Hockney. From writers such as Sappho, Oscar Wilde and Gertrude Stein. To architects such as Philip Johnson. Actors such as Rock Hudson and Jodie Foster. Journalists such as Don Lemon, Anderson Cooper and Rachel Maddow. Fashion designers such as Yves Saint Laurent and Tom Ford. And of course, photographers such as Bernice Abbott, Minor White, Horst, Mapplethorpe, Leibovitz, LaChapelle and Opie. Alternative sexuality or gender practices and extraordinary talent in arts and culture often seem to be intertwined.

So the assemblage of LGBTQ creative and cultural leaders in my book should come as no surprise. Some viewers may love photographs of celebrities and some may find them tiresome. Personally, I find high profile subjects and everyday individuals equally interesting. Yet I can understand why many people are particularly drawn to celebrity photographs—we already have a history with many of these subjects. If we loved an actor's movie or a writer's book, it would only be natural to want to know more about their lives.

My photographic style has a hint of camp, a conscious choice in celebration of—as Susan Sontag pointed out—the intersection of a gay sensibility and camp. As a photography and art history

autodidact, most of my style and technique I developed through trial and error. My approach evolved organically over time, as a confluence of related interests in psychology, theater, architecture, urban planning and drawing. It's been influenced primarily by my life experiences and by the everyday world around me.

I attempt to distinguish *Kings & Queens in Their Castles* from other portrait series in a number of aspects. My approach is a blend of portraiture and architectural photography, to illustrate that subjects and environments are a unified fabric. I shoot subjects at home because our natural habitats bring out our character. The LGBTQ person's home is an extension of him/herself. And for a community sometimes obsessed with image and beauty, our living spaces can also be the ultimate in self-expression. With a flair for design, many of these subjects have crafted playful, often outlandish homes that tell stories about their inhabitants.

I use a wide-angle lens and wide depth of field so that neither subject nor home predominates. Conventional portraiture, on the other hand, tends to emphasize the person, through backgrounds of streamlined simplicity often with a narrow depth of field. I often seek out backdrops and angles packed wall-to-wall with idiosyncratic belongings, paraphernalia and detail, albeit balanced by sweeping exterior shots. Making use of the full color palate, I attempt to uncover what such homes reveal about how multifarious LGBTQ personalities can be.

To fully create 360-degree portraits, I photograph people in daily activity—modern day tableaux vivants. I seek out whimsical, intimate moments of everyday life that shift between the pictorial and the theatrical. While the images often have an element of voyeurism, my subjects occasionally look at the camera as in reality, when being photographed subjects are typically aware of a photographer's presence. I strive for the images to look naturally lit by ambient light, yet most shots are lit with a mixture of tungsten and strobe lights. Almost all shots are hand held (no tripod) and almost all are 35mm digital (although my first book, *Kings in Their Castles*, was mostly film).

I found subjects through thousands of hours of research, letter writing, phone calls, networking, and posting requests on public message boards and social media groups. The subjects in the series are by no means a representative social, economic or ethnic cross section of LGBTQ America. Yet a broad spectrum of geographies and professions are represented. Alongside creatives such as artists, fashion designers, writers, actors, directors, music makers and dancers, I feature business leaders, politicians, journalists, activists and religious leaders. I include those who keep our country running, such as farmers, beekeepers, police officers, doctors, chefs, bartenders and innkeepers. I exhibit some miscellaneous athletes, students, professors, drag queens and socialites. As well as a cartoonist, barista, poet, comedian, navy technician and paleontologist. I also showcase urban bohemians, beatniks, mavericks and iconoclasts, many of whom blossomed in the 1960s and 1970s but seem to be slowly disappearing. It should be noted that a few people in the series are straight friends who happened to be visiting subjects when I was shooting.

Ultimately, I record the personal landscapes of these subjects for them to become works of art in their own right. With elements of both formal portraiture and informal snapshots, my images attempt to dance the line between beauty and chaos, sometimes simultaneously comforting and unsettling. I hope that you find the sum of these photographs inspiring and moving and that they arouse in you as much delight and curiosity as they do in me. I invite you to view dozens more photographs at www.TomAtwood.com.

—Tom Atwood

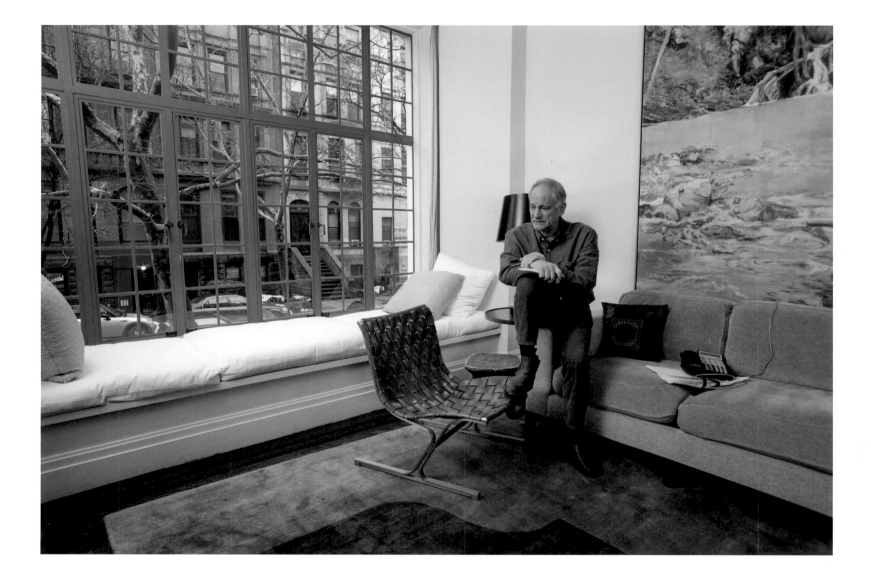

John Berendt, author of *Midnight in the Garden of Good and Evil*, *The City of Falling Angels*
New York, NY

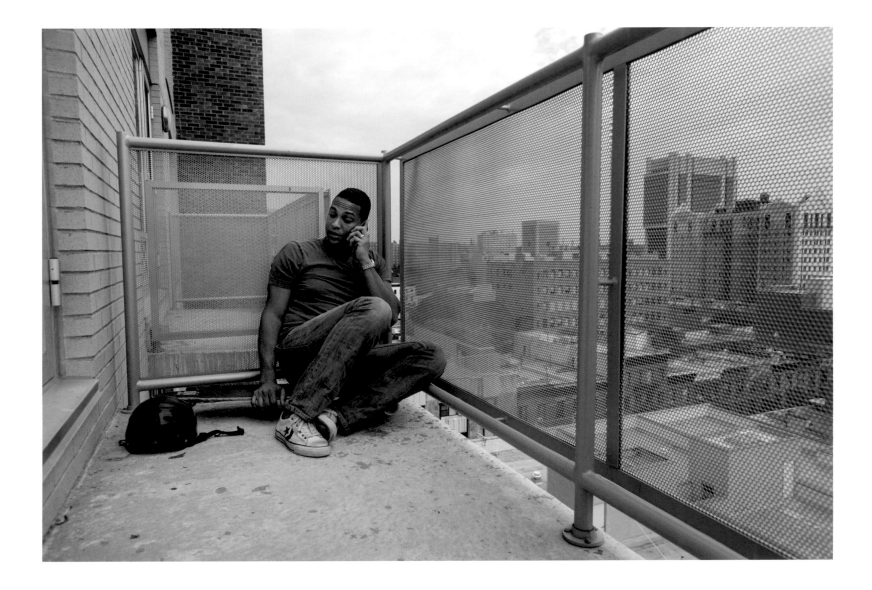

Don Lemon, CNN anchor
New York, NY

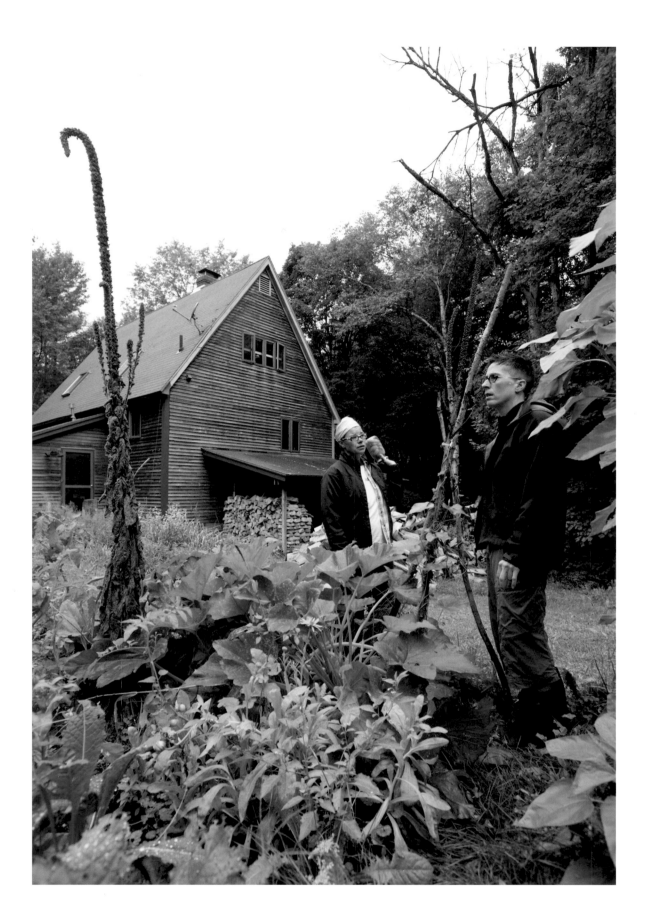

Holly Taylor, compost maven
Alison Bechdel, cartoonist, MacArthur Genius Grant winner and author of *Fun Home*
Jericho, VT

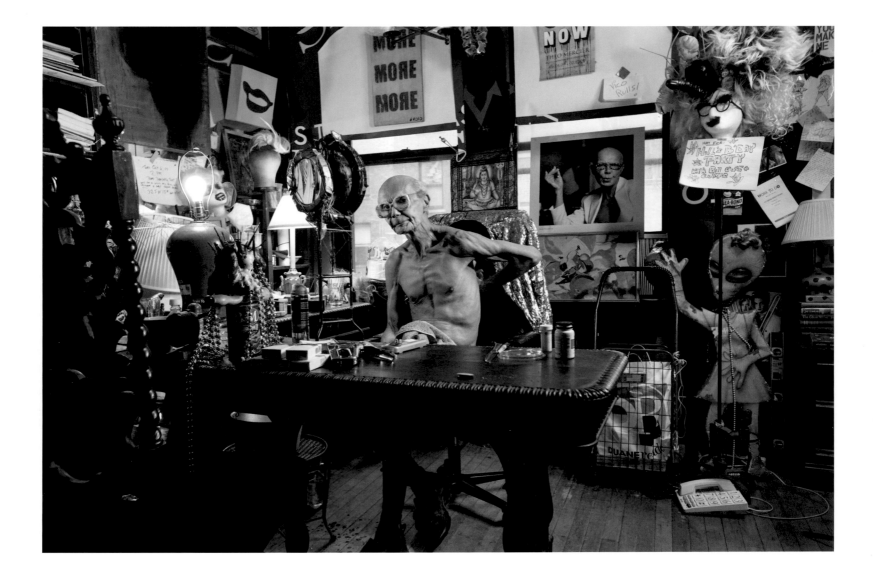

Mother Flawless Sabrina, female impersonator

New York, NY

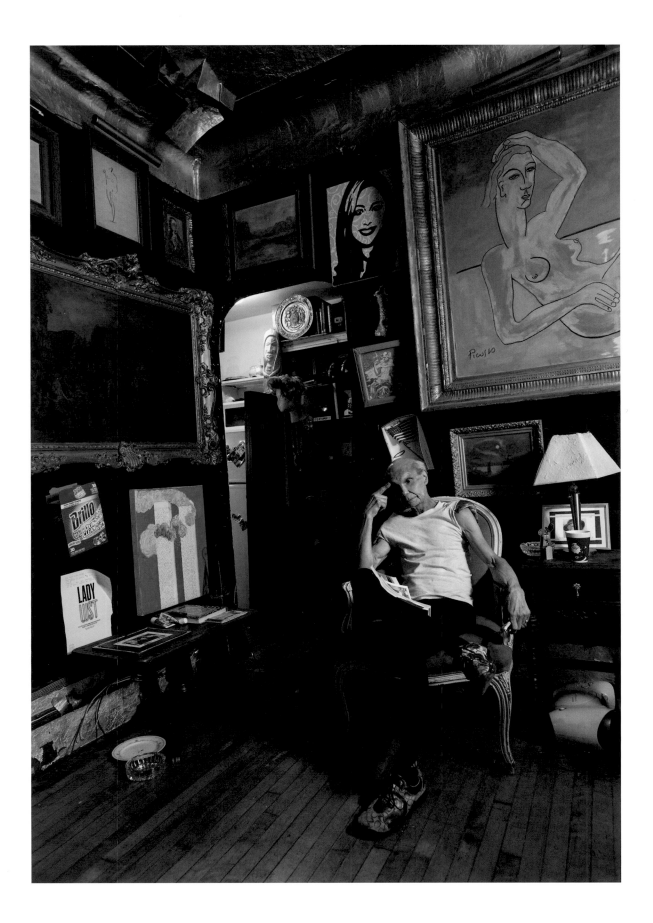

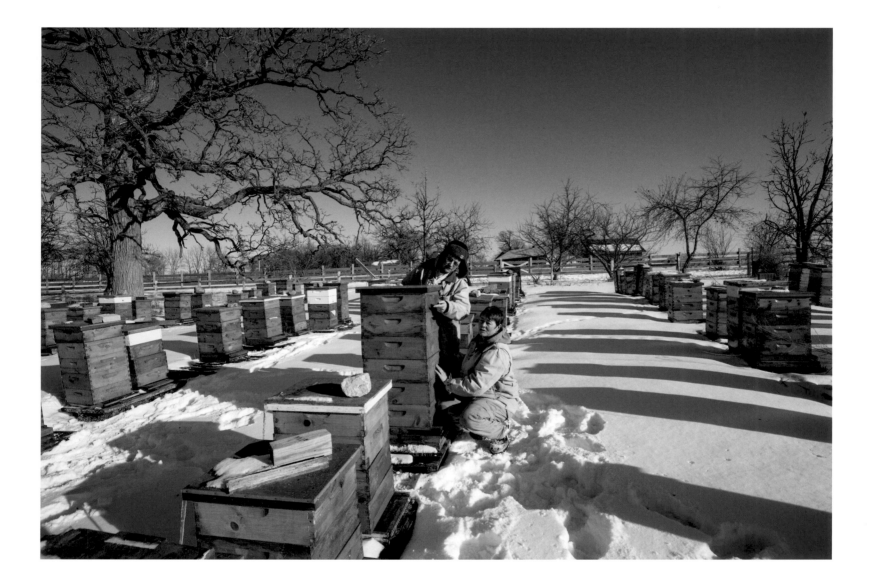

Mary Celley and **Sue Williams**, beekeepers

Brooklyn, WI

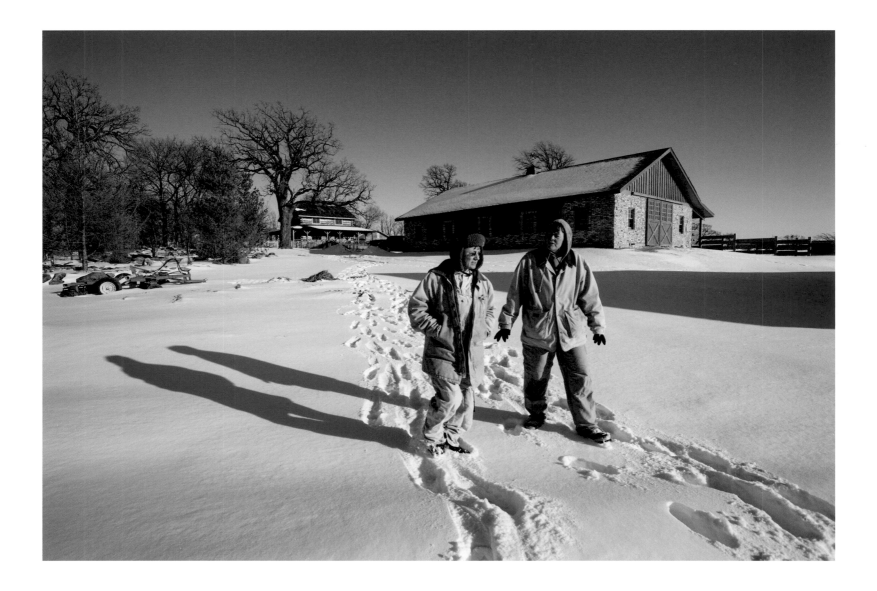

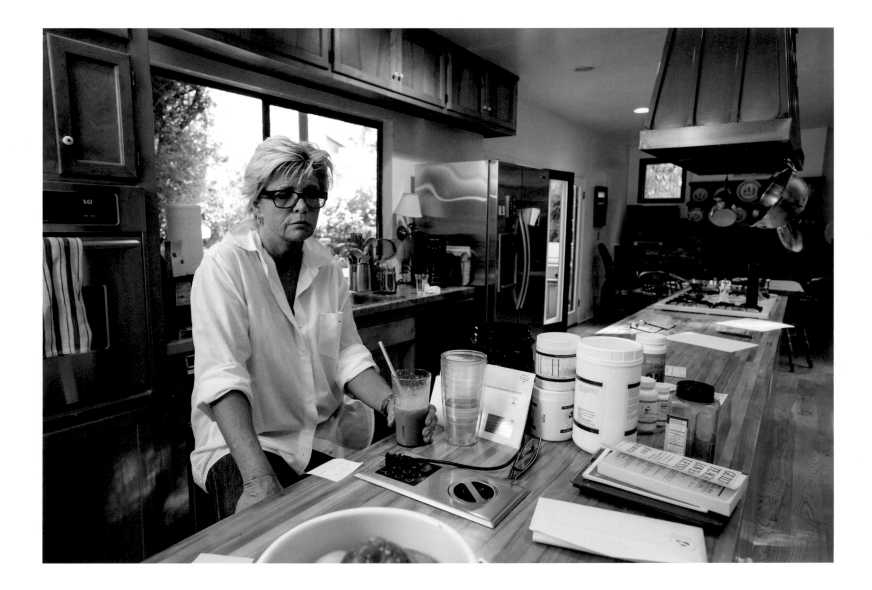

Meredith Baxter, actress from *Family Ties*, *All the President's Men*, *Glee*, *Family*
Santa Monica, CA

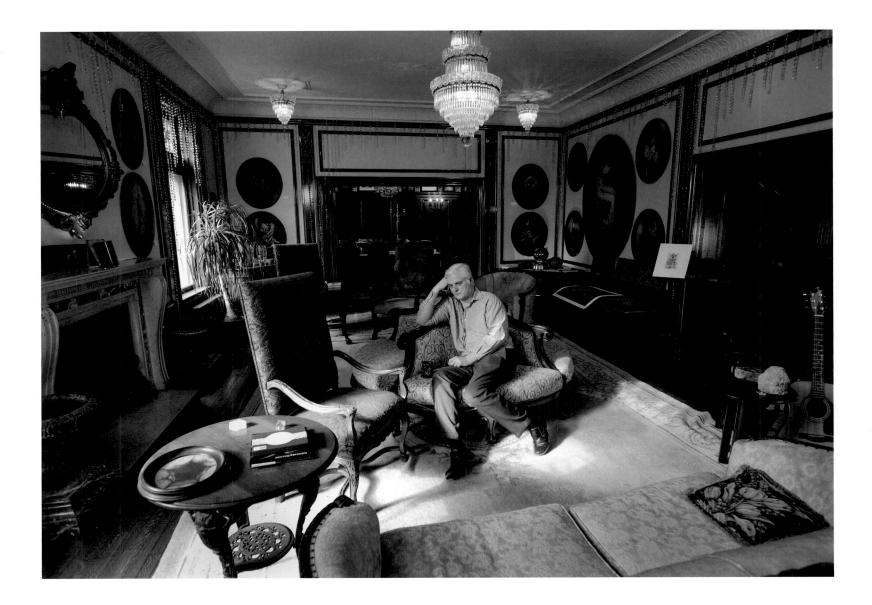

David Teplica, plastic surgeon

Chicago, IL

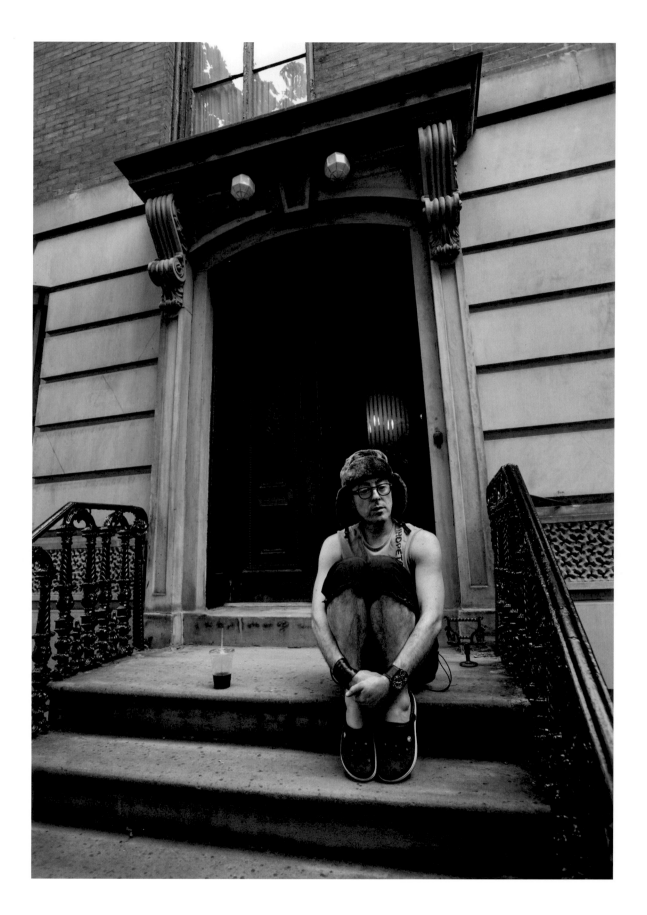

Alan Cumming, Tony-winning actor from *Hamlet*, *Macbeth*, *Cabaret*
New York, NY

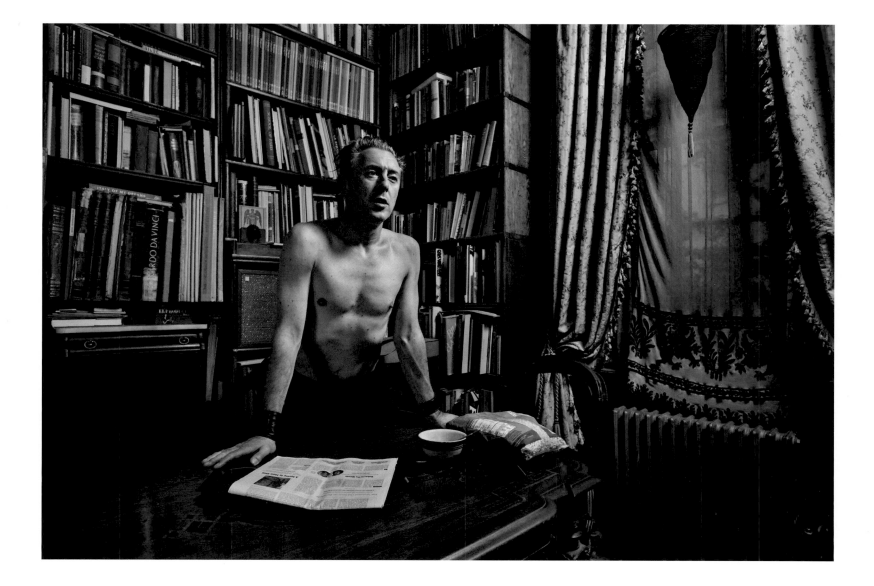

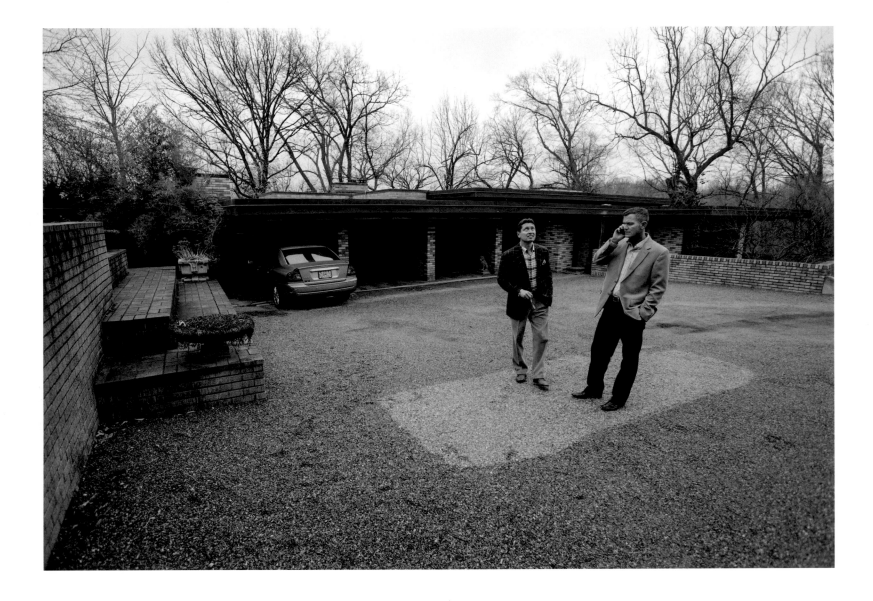

Jim Blair, small business owner
Kevin Hancock, investment banker
In front of their Frank Lloyd Wright house
Kansas City, MO

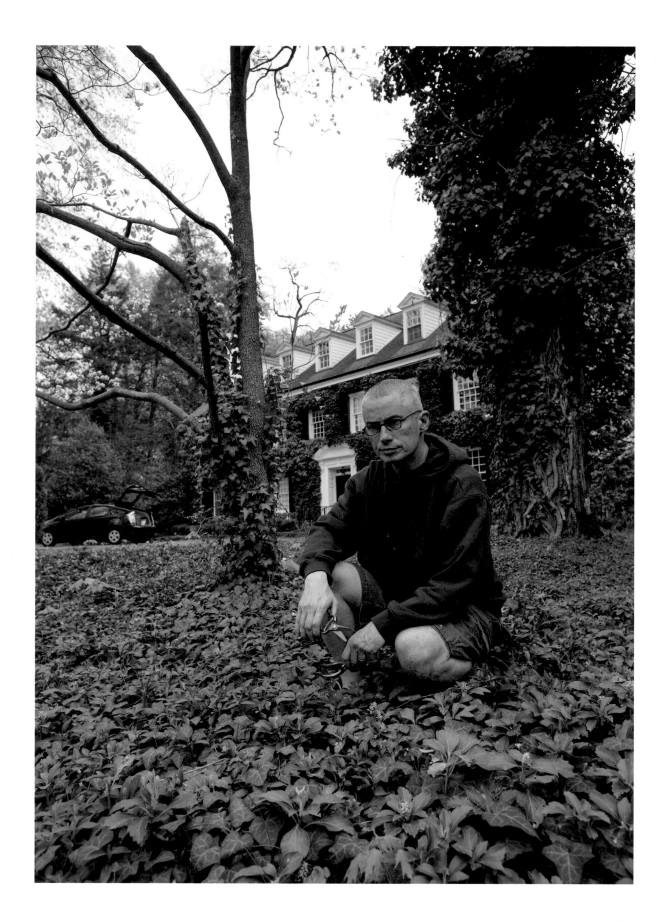

Jim McGreevey, former New Jersey Governor
Plainfield, NJ

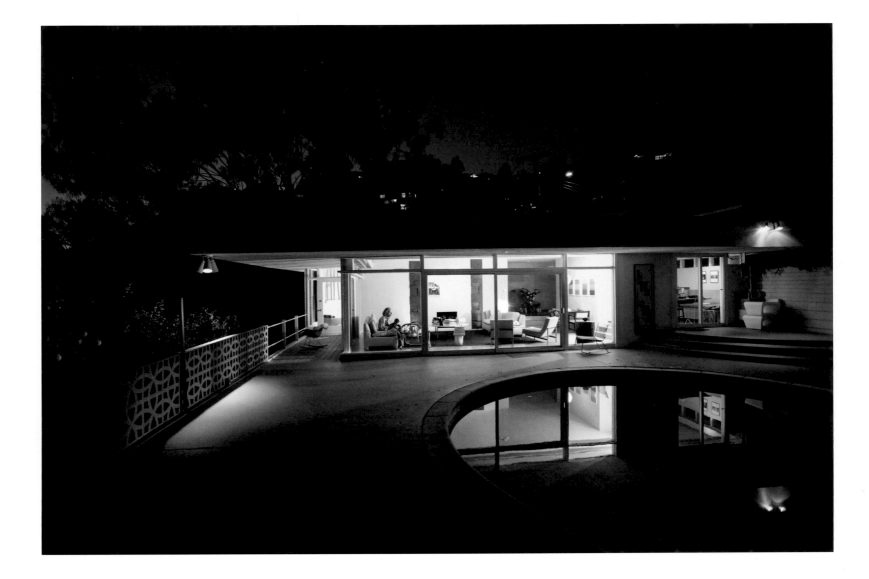

Bruce Cohen, producer of *American Beauty*, *The Nines*, *Big Fish*, *The Forgotten*, *Milk*
Los Angeles, CA

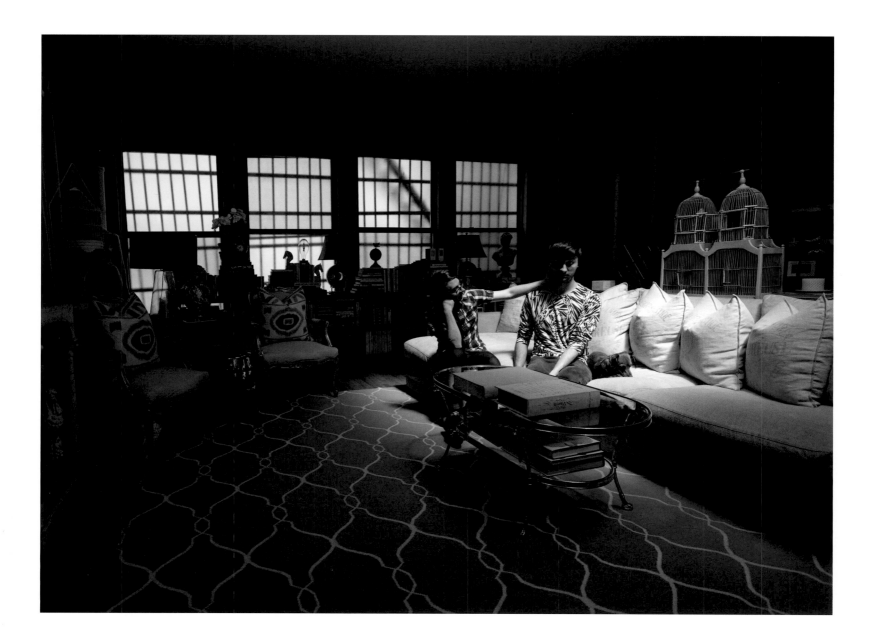

Christian Siriano, *Project Runway* winner
Brad Walsh, singer
New York, NY

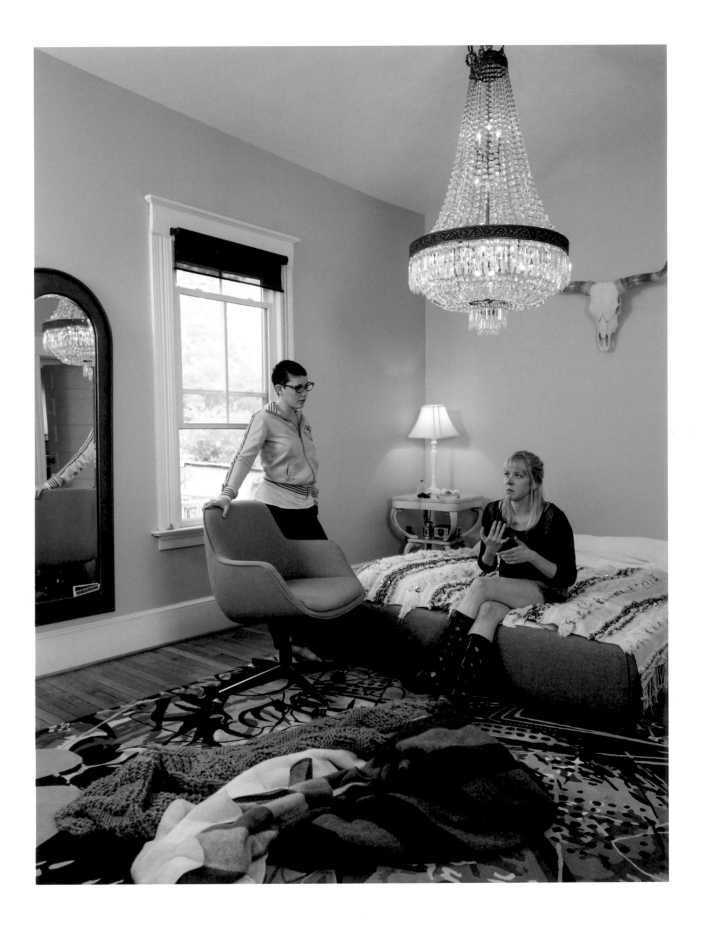

Victoria Facelli (friend), performance artist
Kate Swearingen, clinical trial manager
Durham, NC

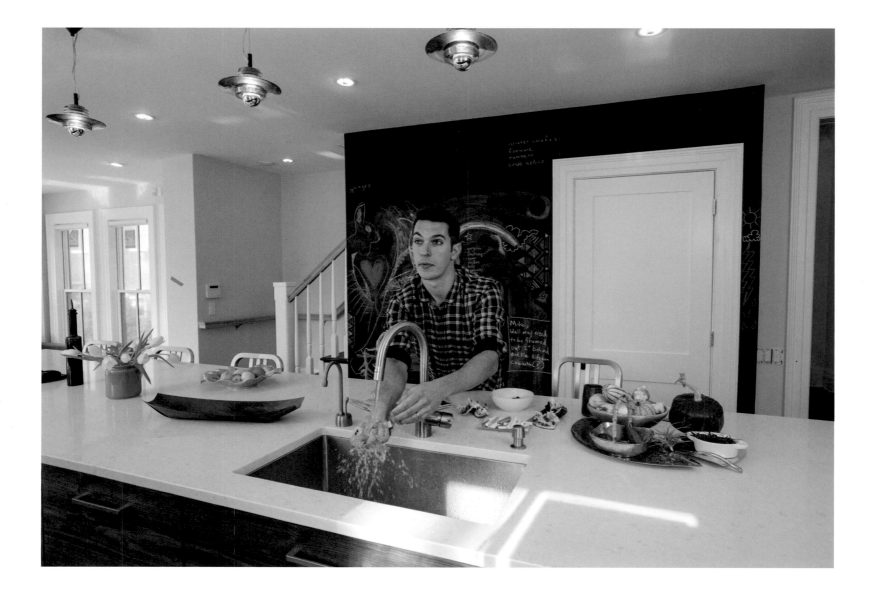

Ari Shapiro, co-host of NPR's *All Things Considered*
Washington, D.C.

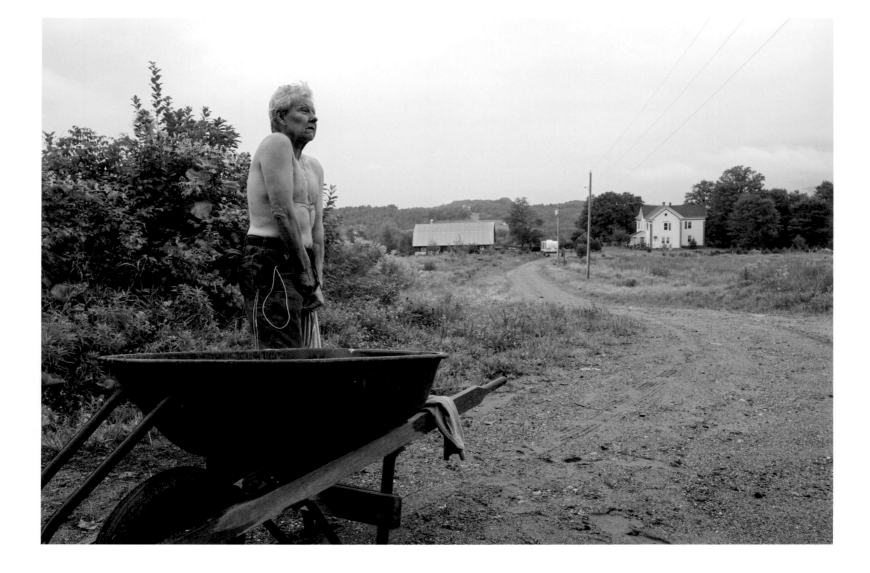

Anthony Barreto-Neto, transgender deputy sheriff
Barton, VT

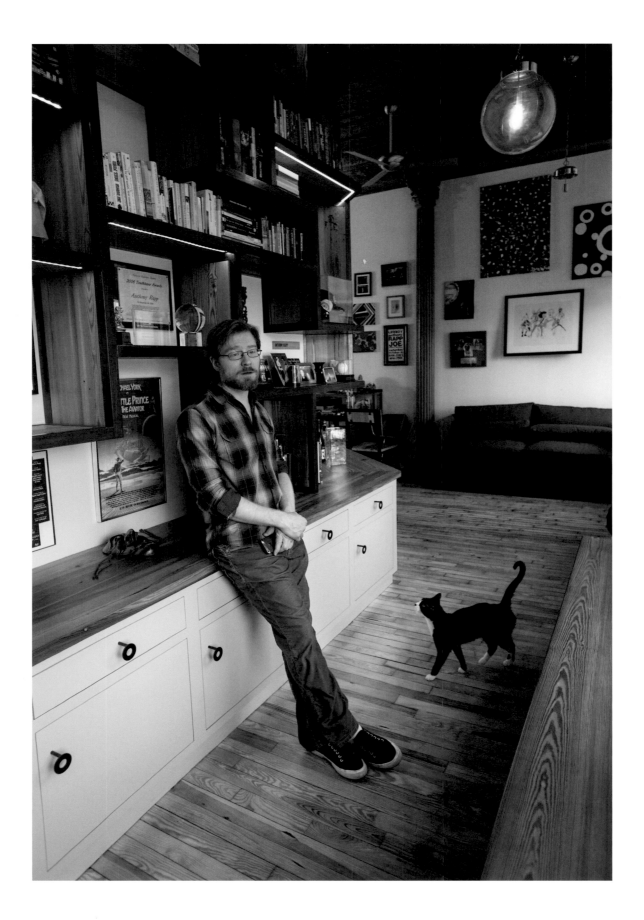

Anthony Rapp, actor from *Rent*, *Dazed and Confused*, *Psych*, *A Beautiful Mind*
New York, NY

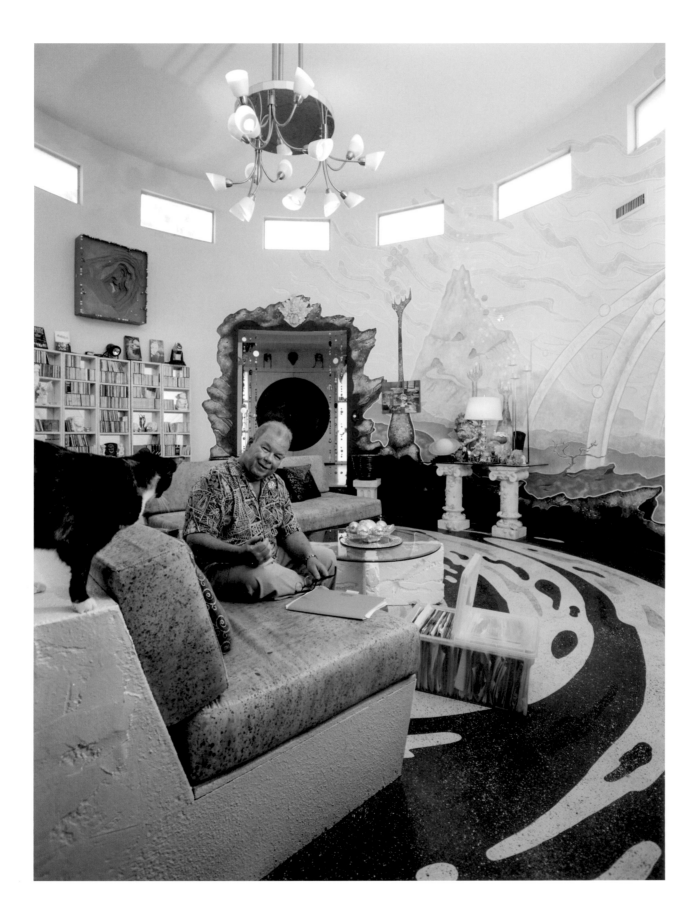

Drew Hunter, amusement park designer
Jacksonville, FL

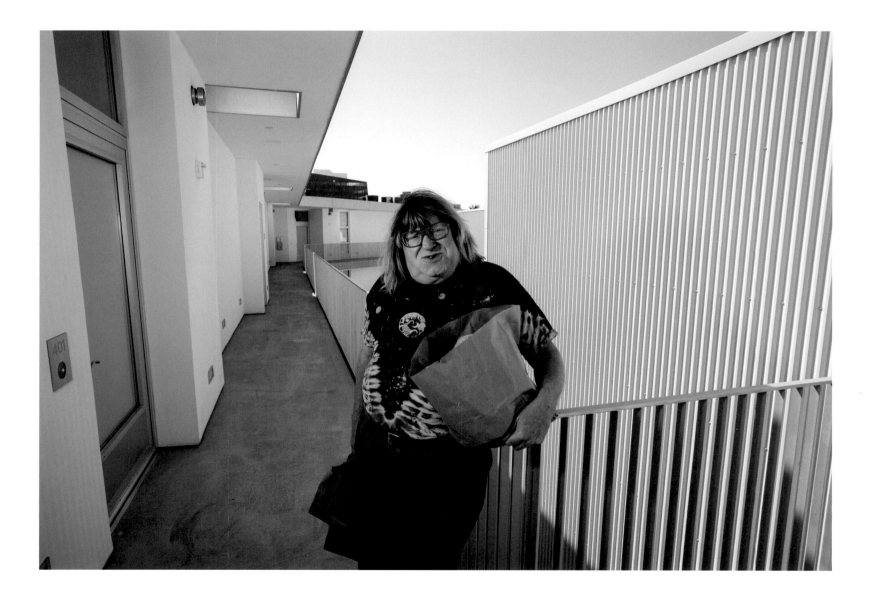

Bruce Vilanch, Emmy-winning celebrity from *Hollywood Squares*
West Hollywood, CA

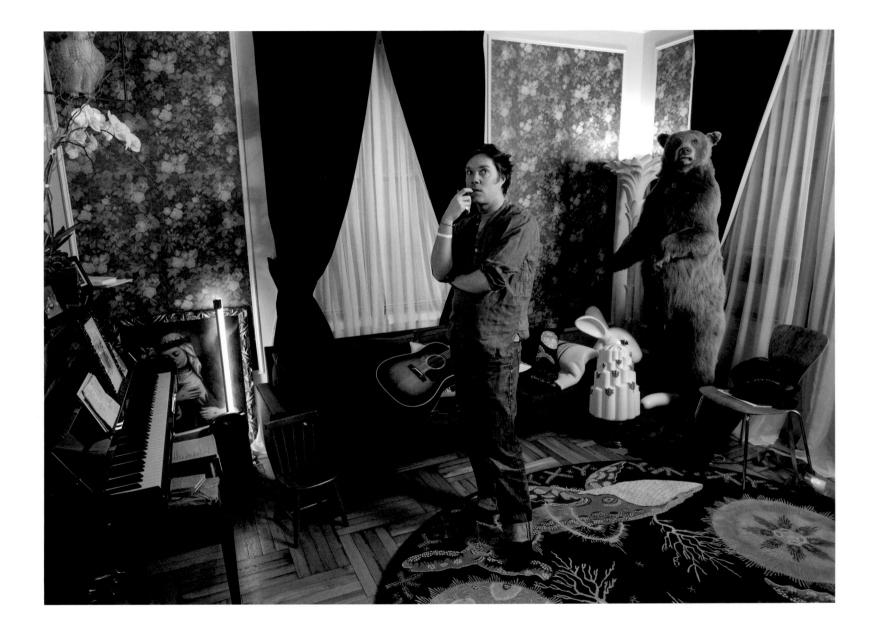

Rufus Wainwright, award-winning singer and songwriter
New York, NY

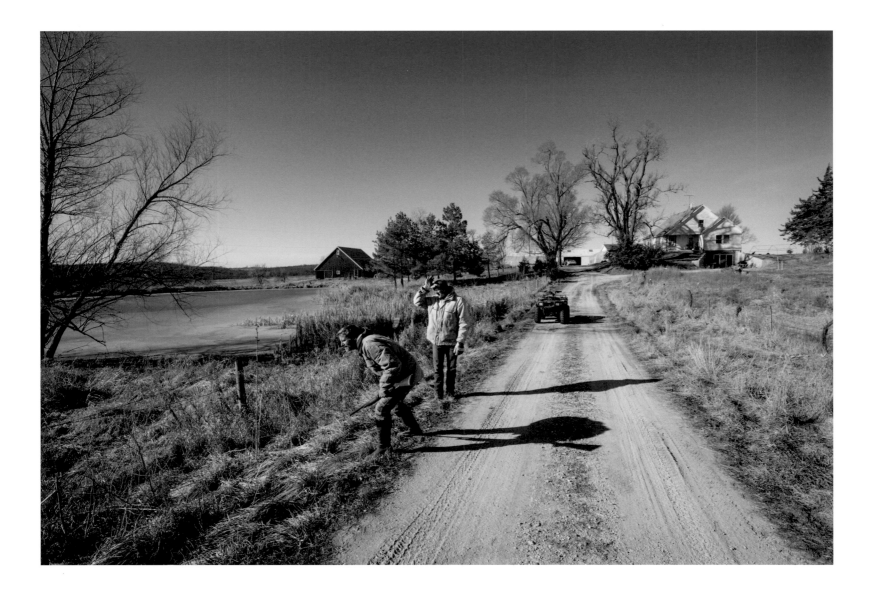

Patrick Standley and **Matt Russell**, farmers
Searching for a critter
Lacona, IA

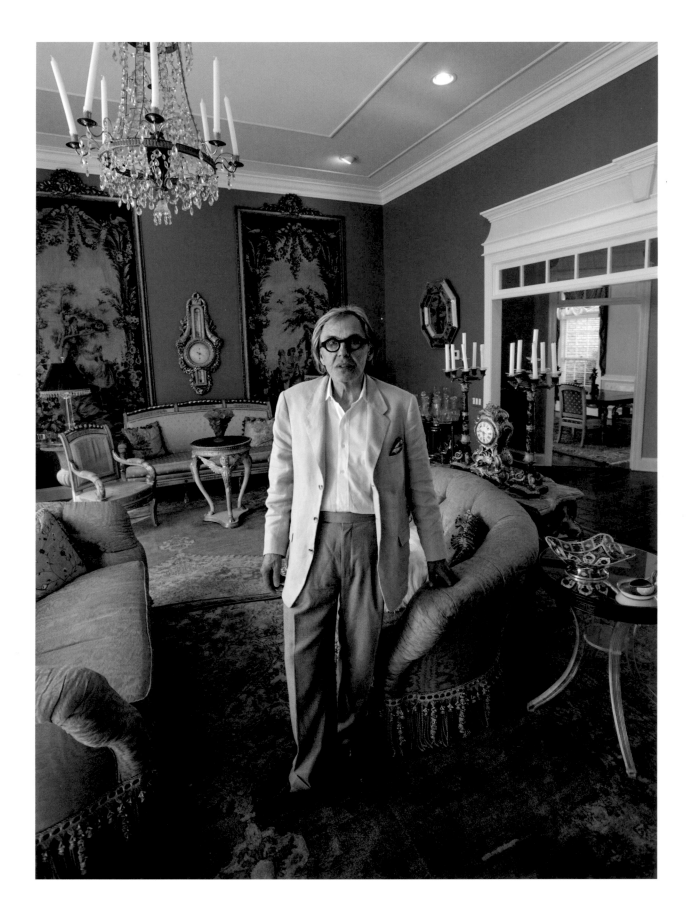

Gary Tisdale-Woods, community volunteer
Greensboro, GA

Michael Urie, actor from *Ugly Betty*, *The Good Wife*, *Partners*, *Modern Family*
New York, NY

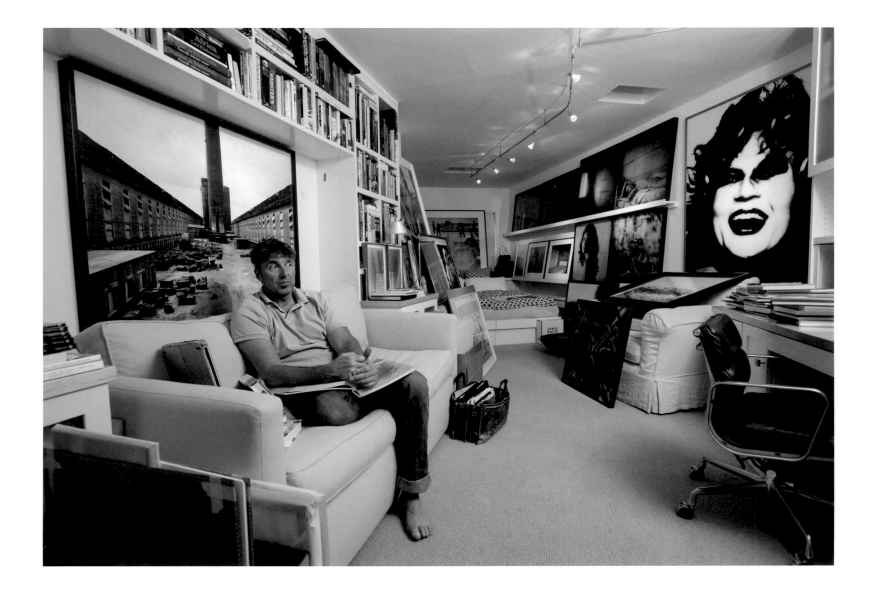

Kai Loebach, caterer and photography collector
Los Angeles, CA

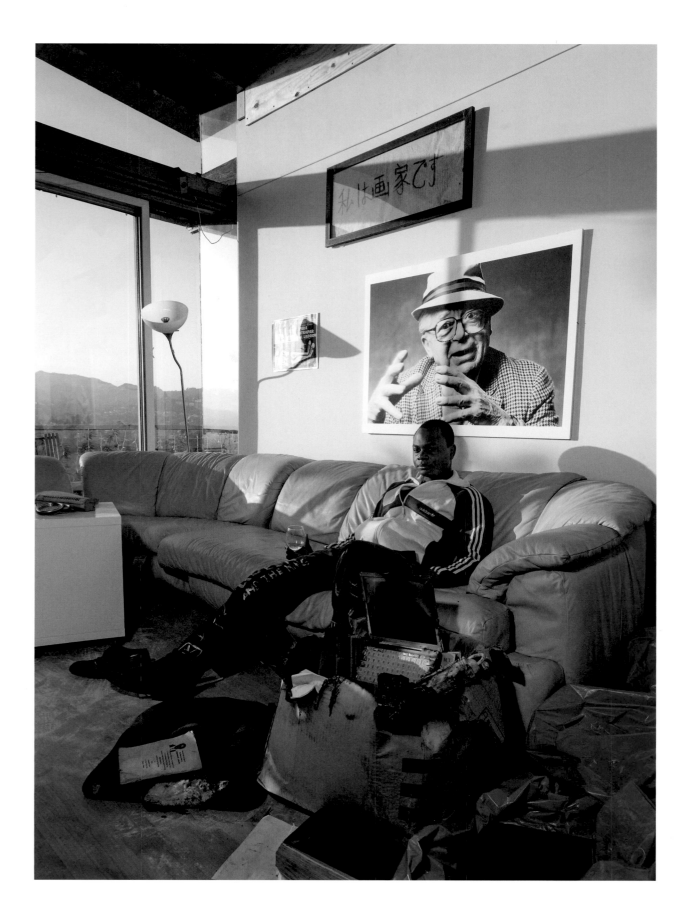

Atu Darko, television executive
Shortly after a fire at home
Los Angeles, CA

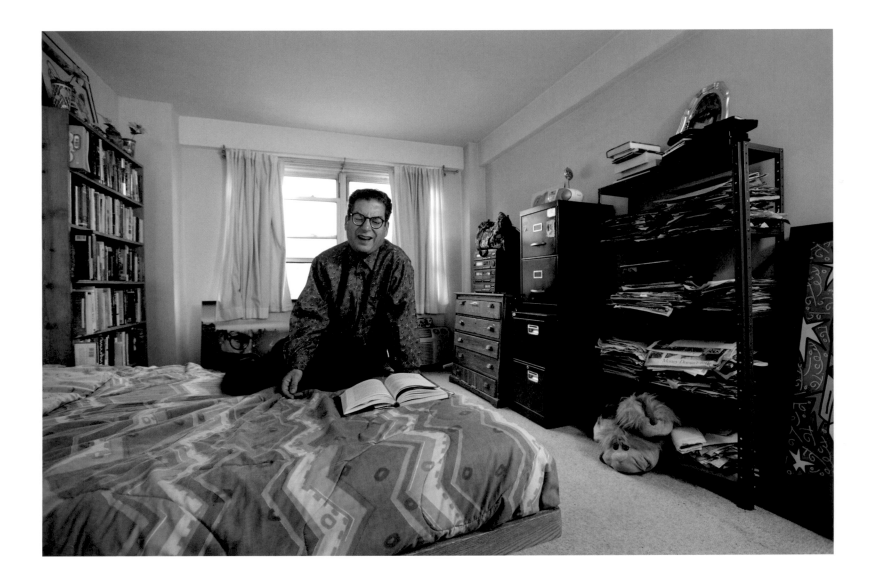

Michael Musto, *Village Voice* columnist and television personality
New York, NY

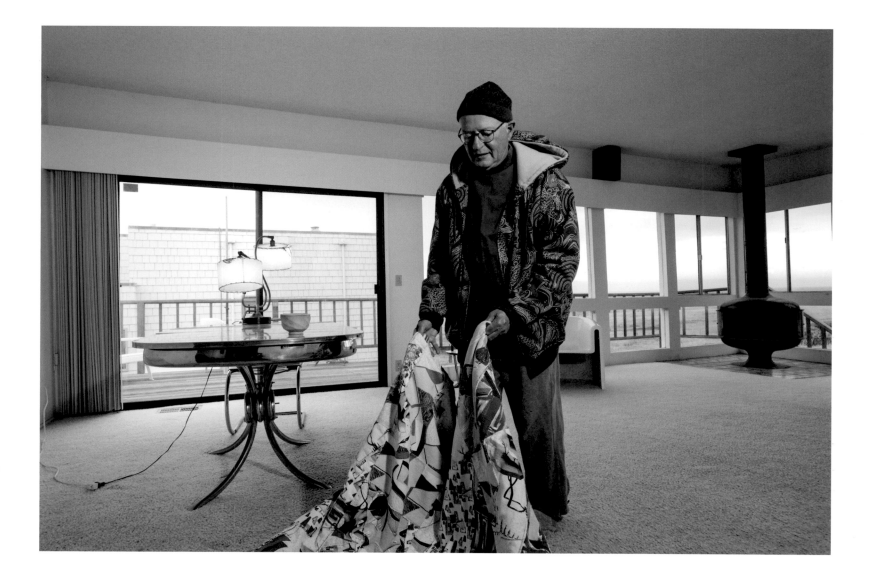

Arthur Tress, renowned photographer
Cambria, CA

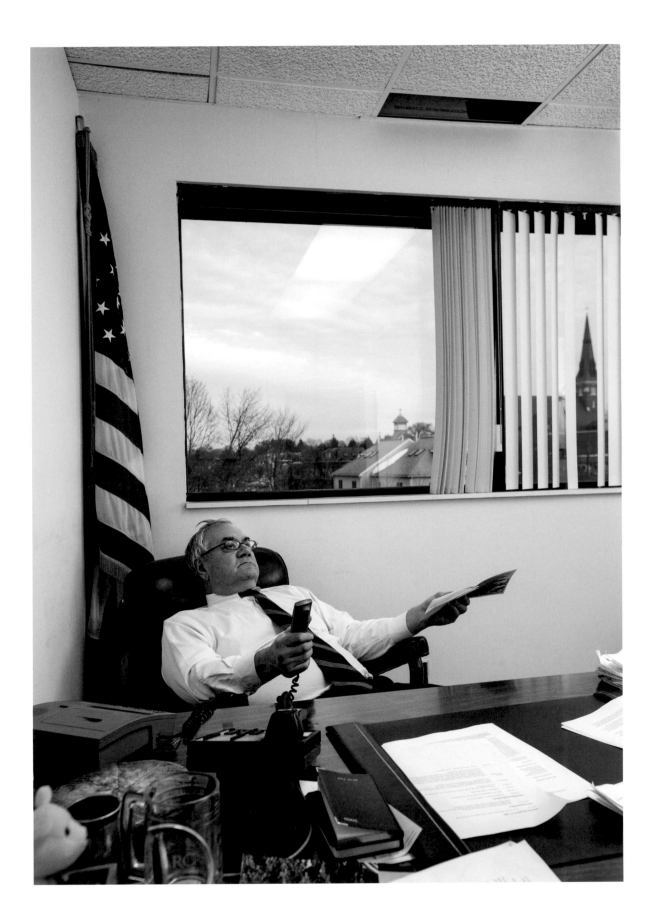

Barney Frank, former US Congressman and chair of Financial Services Committee
Newton, MA

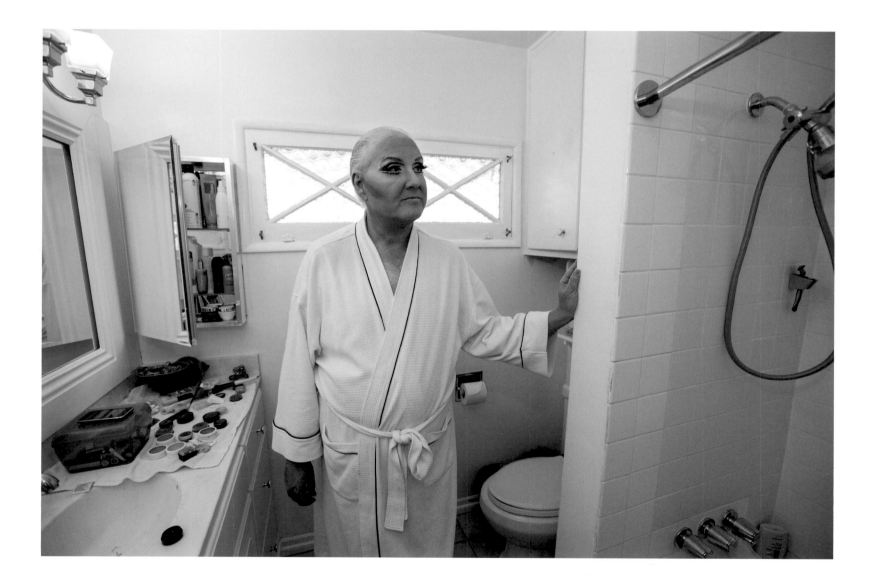

David Meacham, female impersonator
Van Nuys, CA

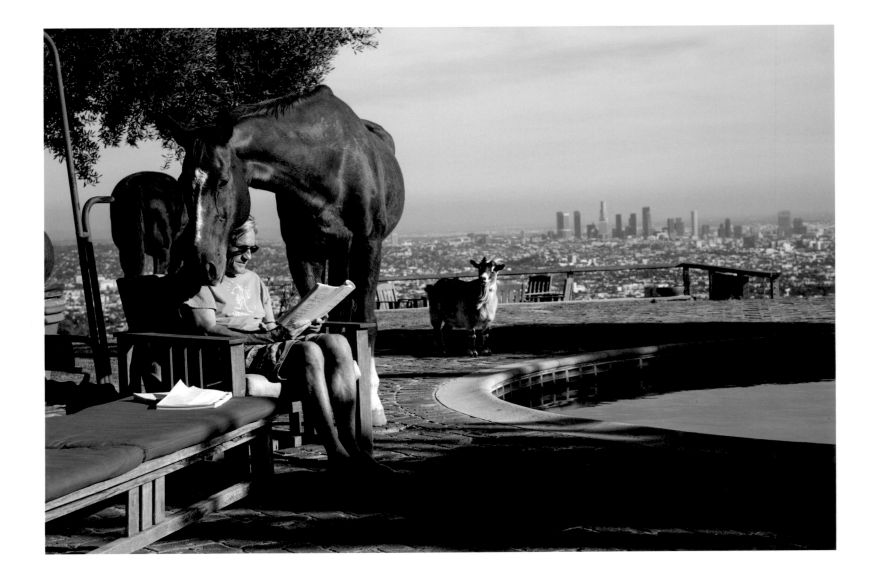

Randal Kleiser, director of *Grease*, *Grandview U.S.A.*, *Big Top Pee-wee*, *The Blue Lagoon*
Los Angeles, CA

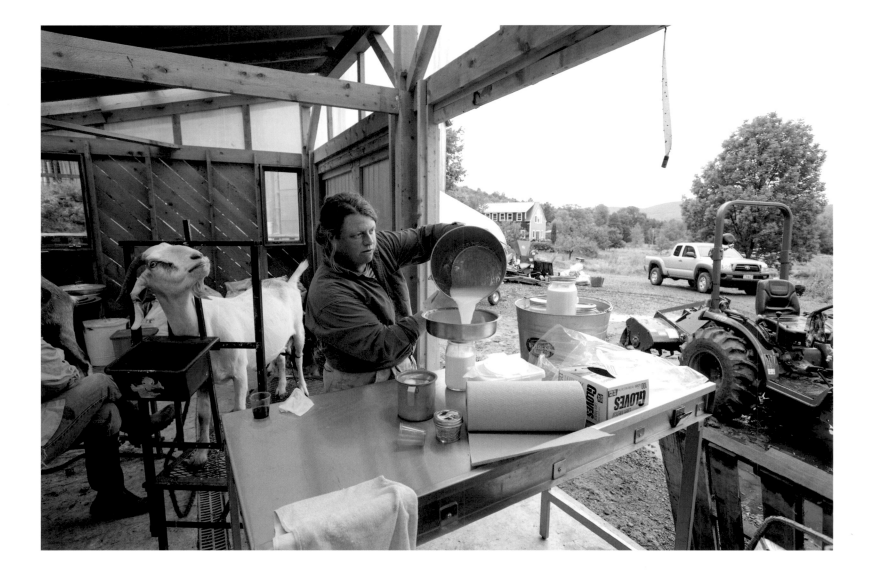

Mari Omland, farmer

Northfield, VT

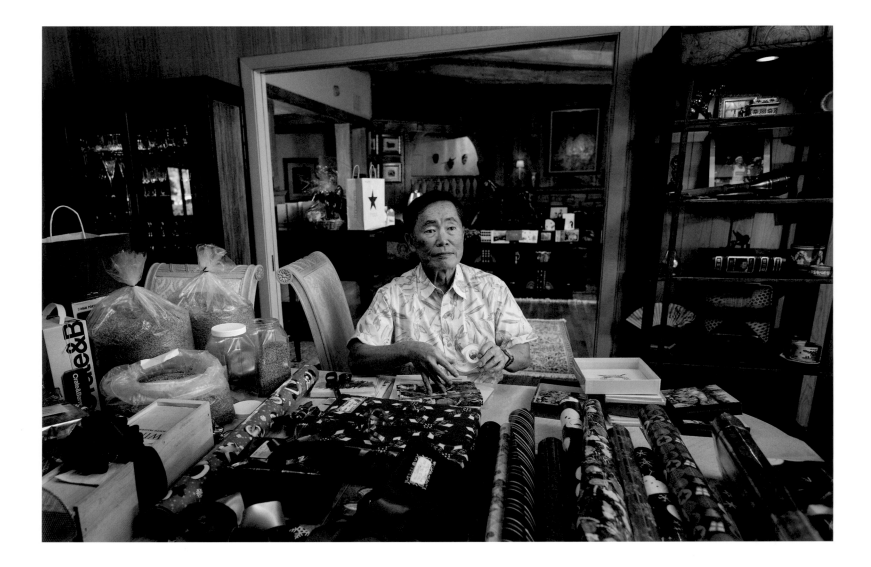

George Takei, actor from *Star Trek*, *The Twilight Zone*, *Star Wars*, *Heroes*
Los Angeles, CA

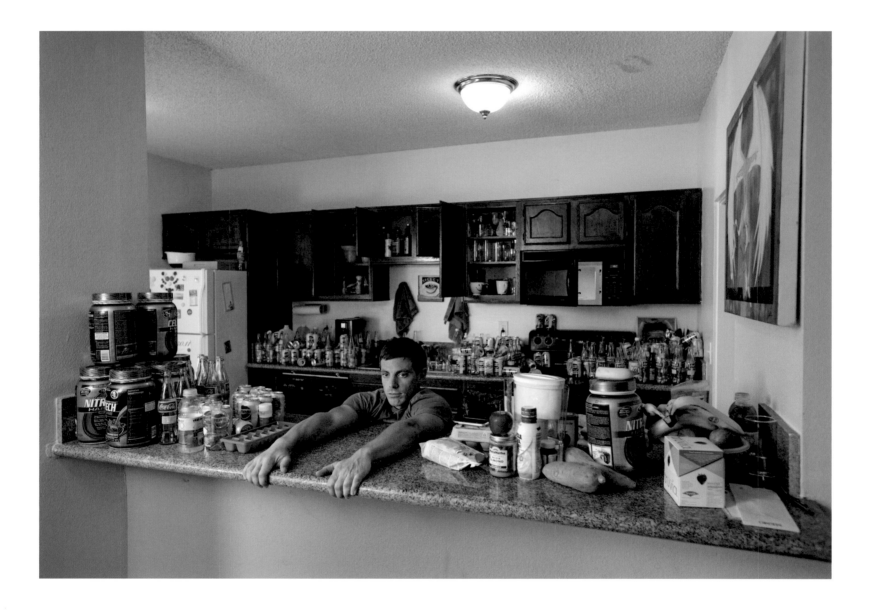

David Moretti, actor from *House of Cards*, *The Lair*, *Scrooge & Marley*, *Arizona*
Los Angeles, CA

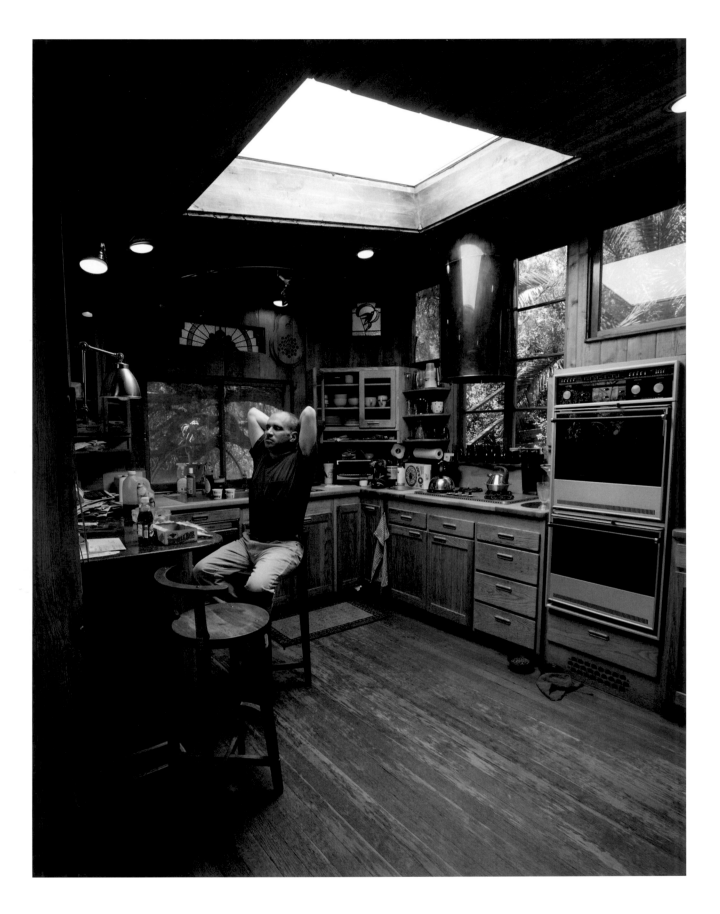

Jonathan Handel, attorney and journalist
Los Angeles, CA

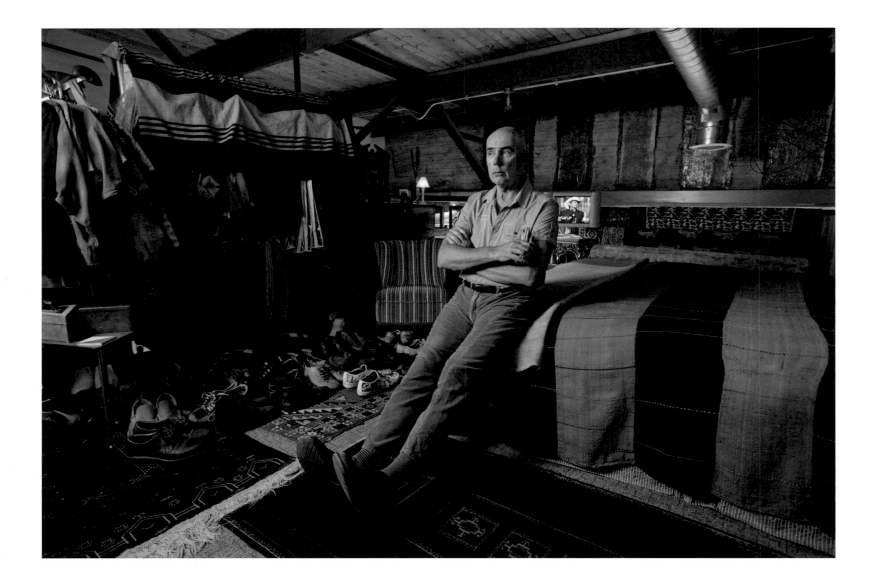

Douglas Nielsen, choreographer
Tucson, AZ

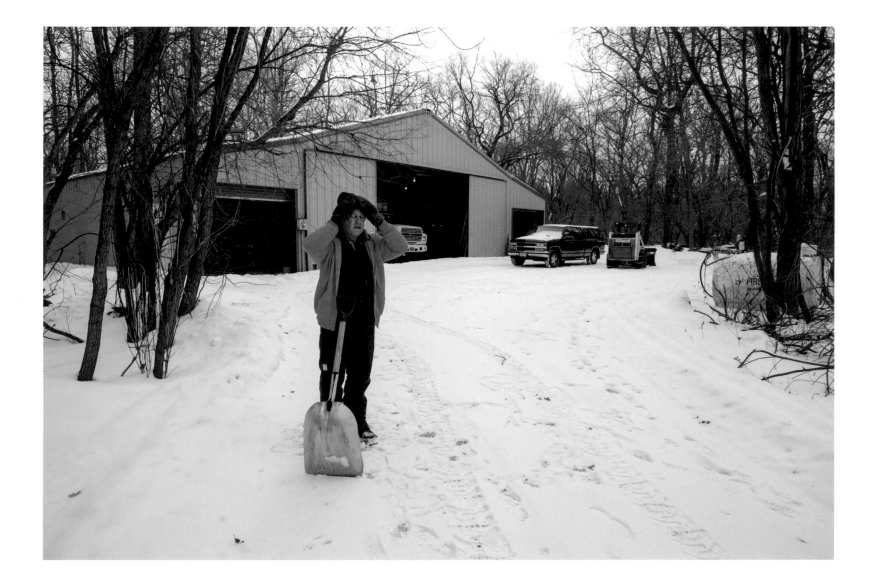

Mark Porter, farmer

Oregon, WI

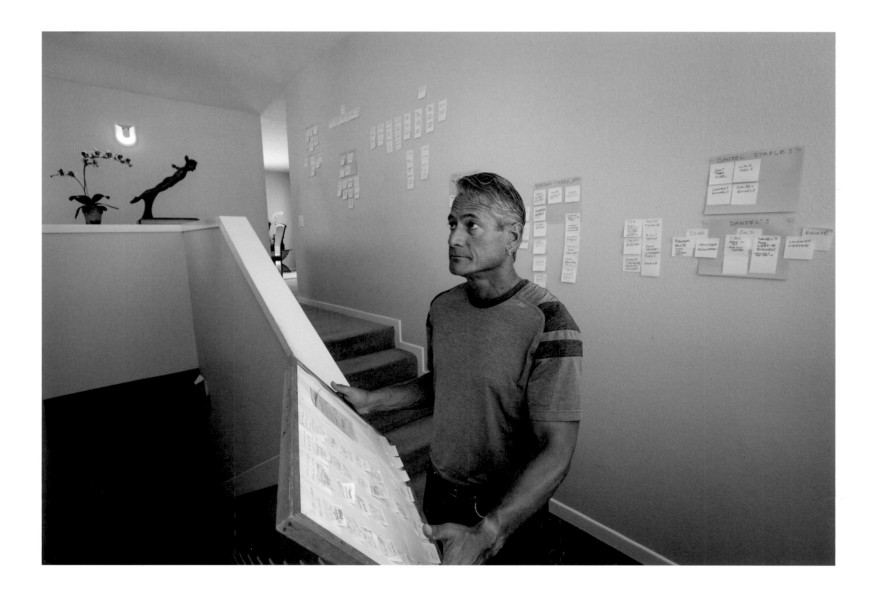

Greg Louganis, Olympic diver and gold medal winner
Malibu, CA

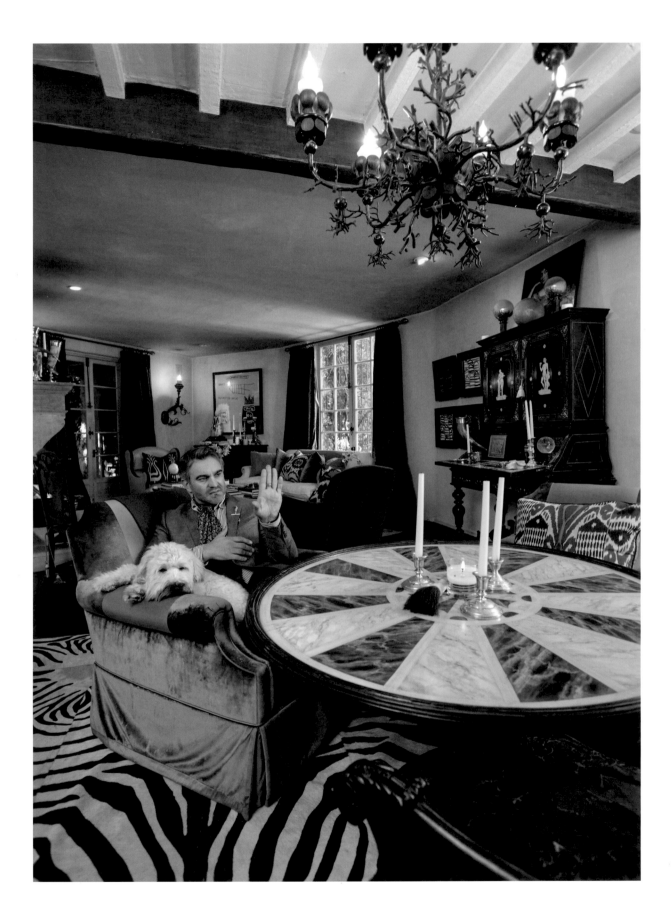

Martyn Lawrence Bullard, star of *Million Dollar Decorators*, *Hollywood Me*
Los Angeles, CA

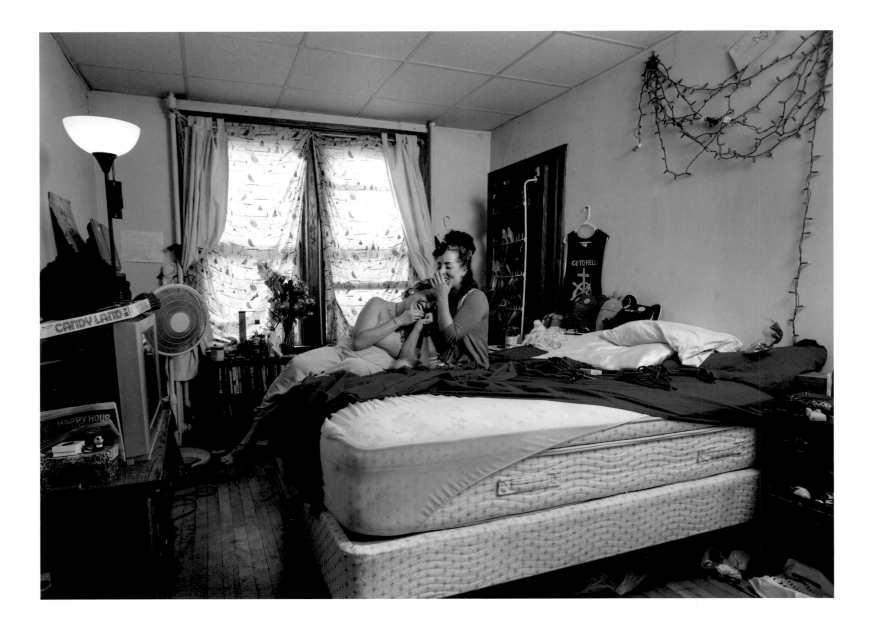

Maggie Zall, activist and sex worker
Nicole Stroumbos (friend), dancer
Portland, ME

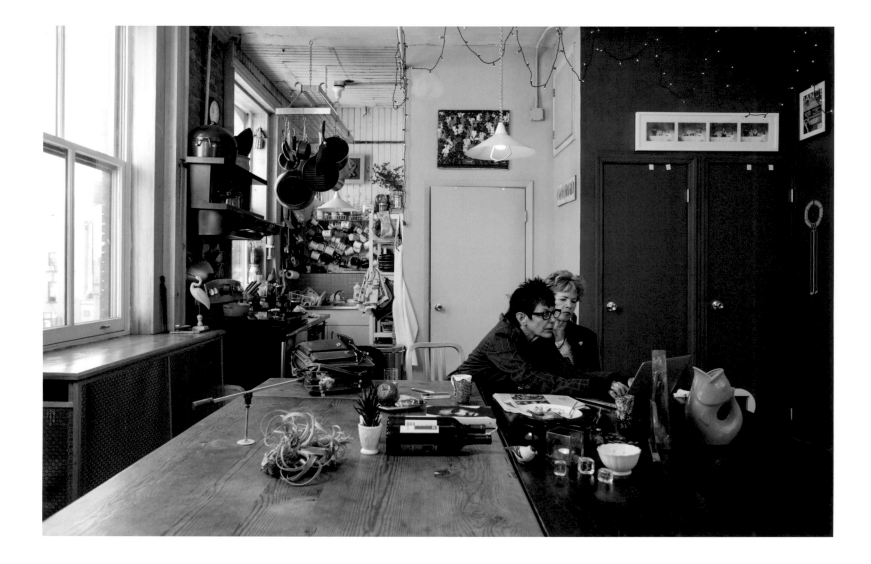

Elizabeth Streb, acclaimed choreographer
Laura Flanders, journalist and Air America Radio host
New York, NY

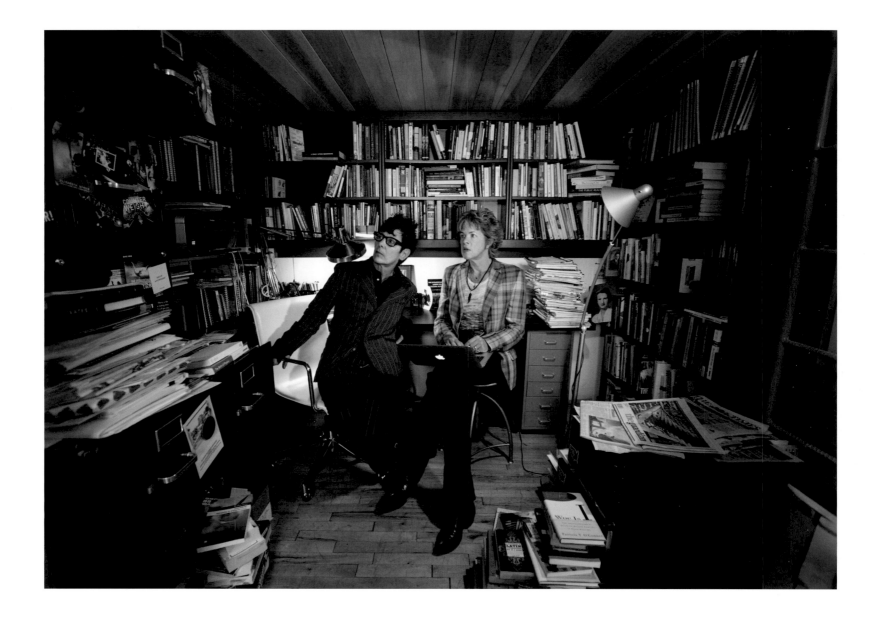

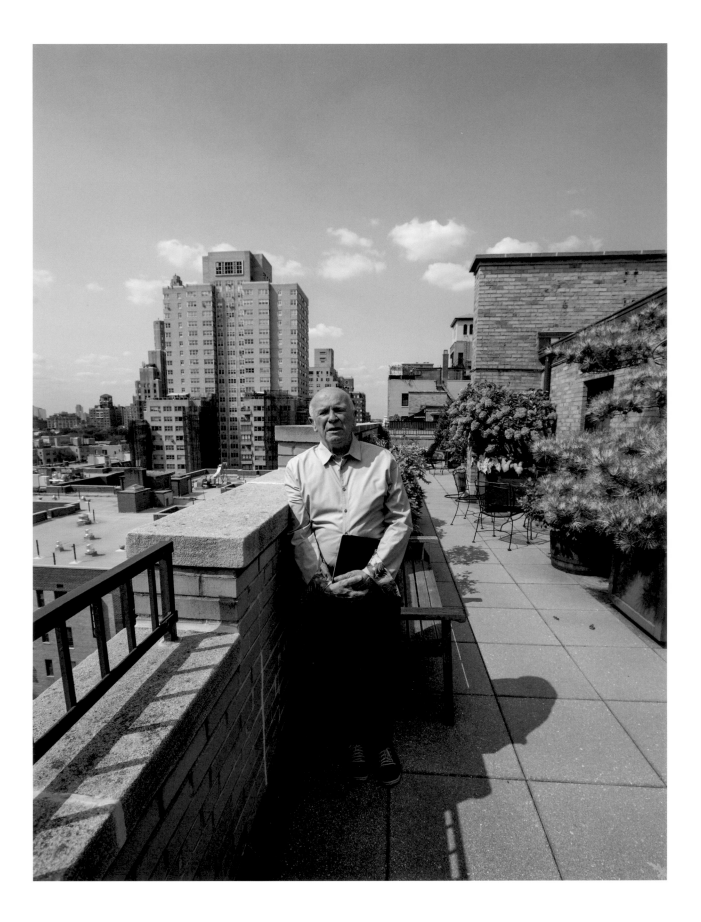

Terrence McNally, Tony and Emmy-winning writer and playwright
New York, NY

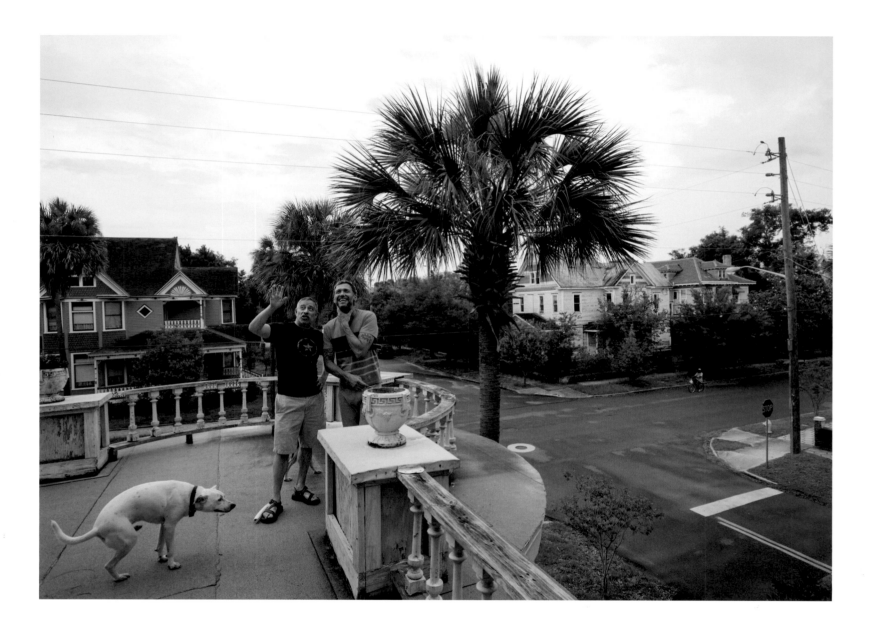

Tom Minette, consultant

Tim Fivecoat (friend), housekeeper

Jacksonville, FL

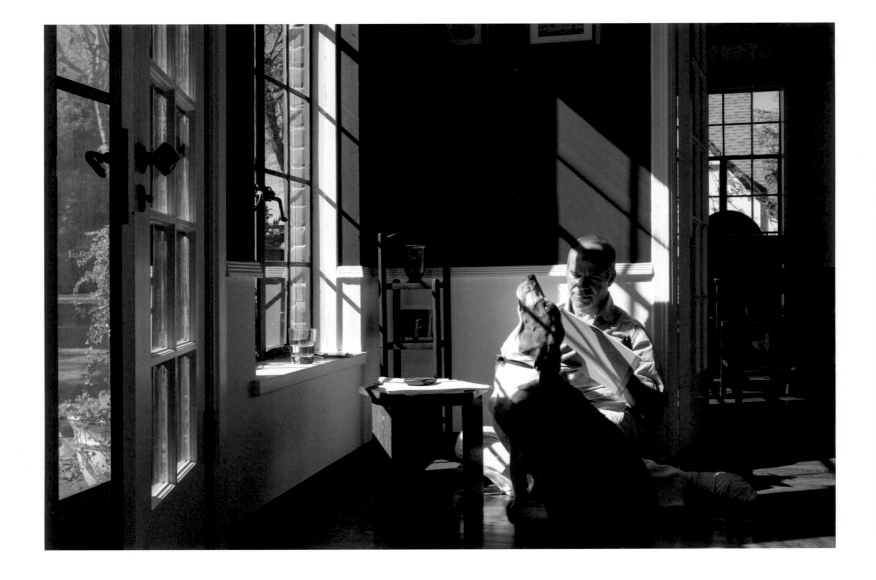

Dean Hansell, lawyer
Los Angeles, CA

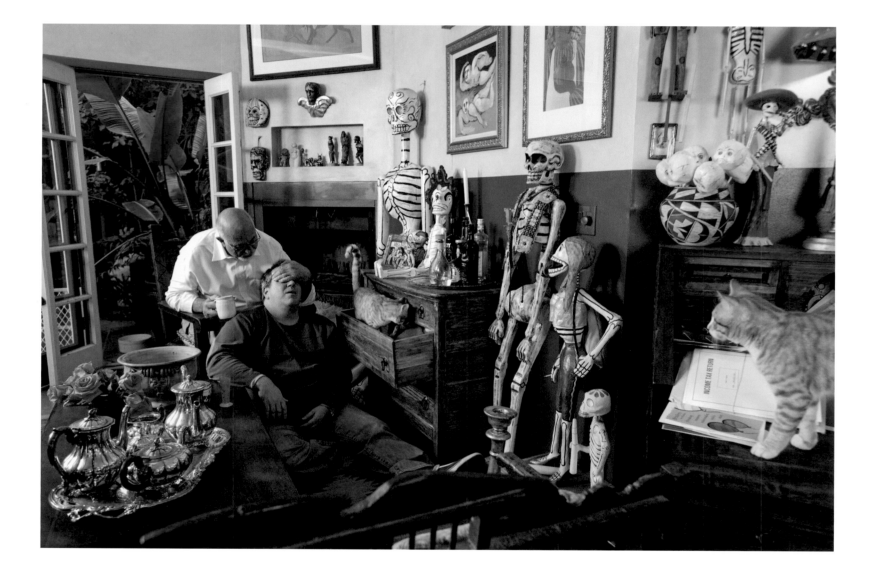

Dan Overbeck, psychologist and hotel operator
Mark Flamini, aid for developmentally disabled
Tucson, AZ

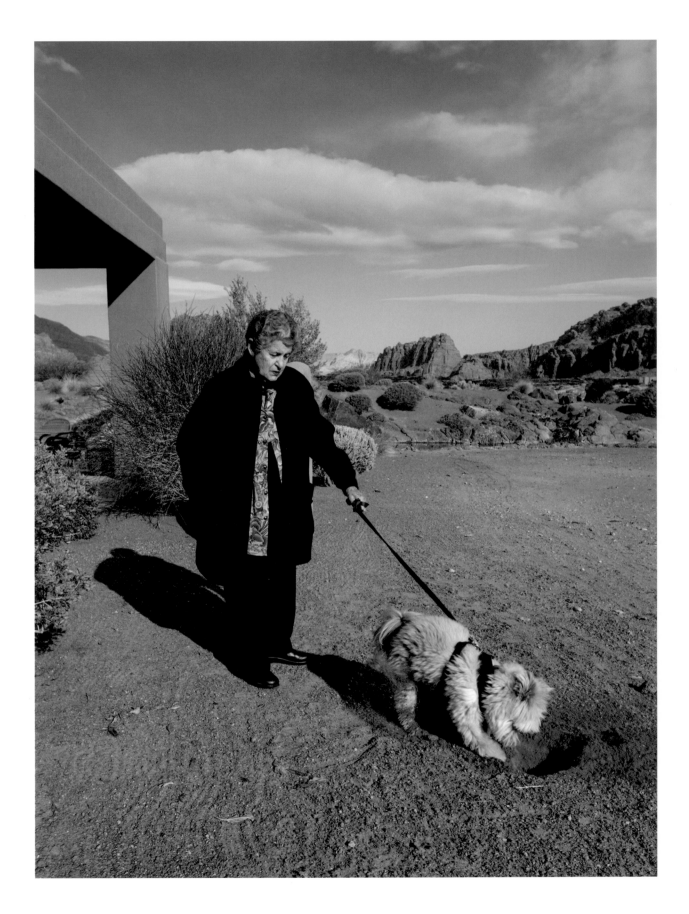

Diane Bernard, social worker
In her back yard
Ivins, UT

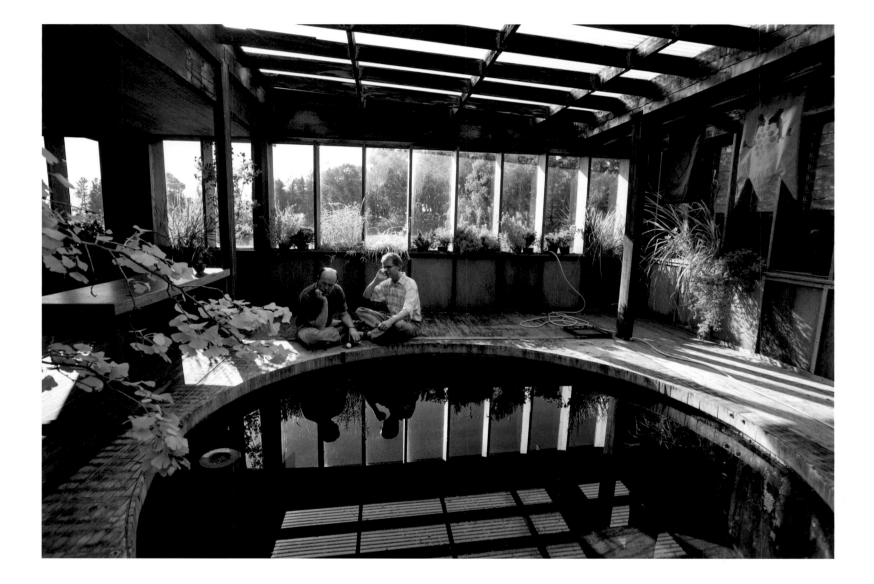

Jeff Mallory, nonprofit trustee
Kevin Smith, writer
Big Sur, CA

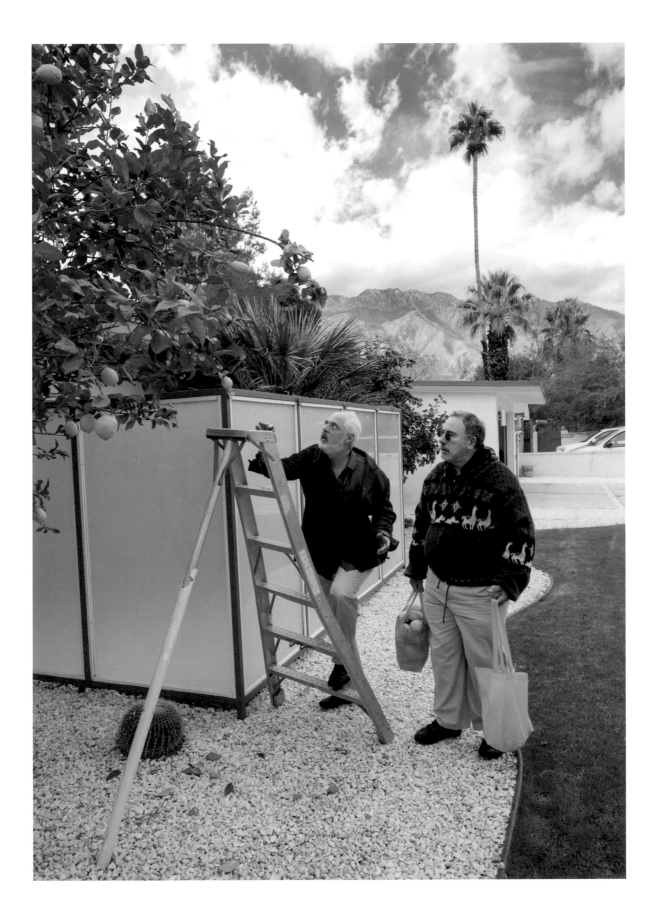

Spencer Throckmorton, gallery director
Kraige Block, gallery director and AIPAD Photography Show committee chair
Palm Springs, CA

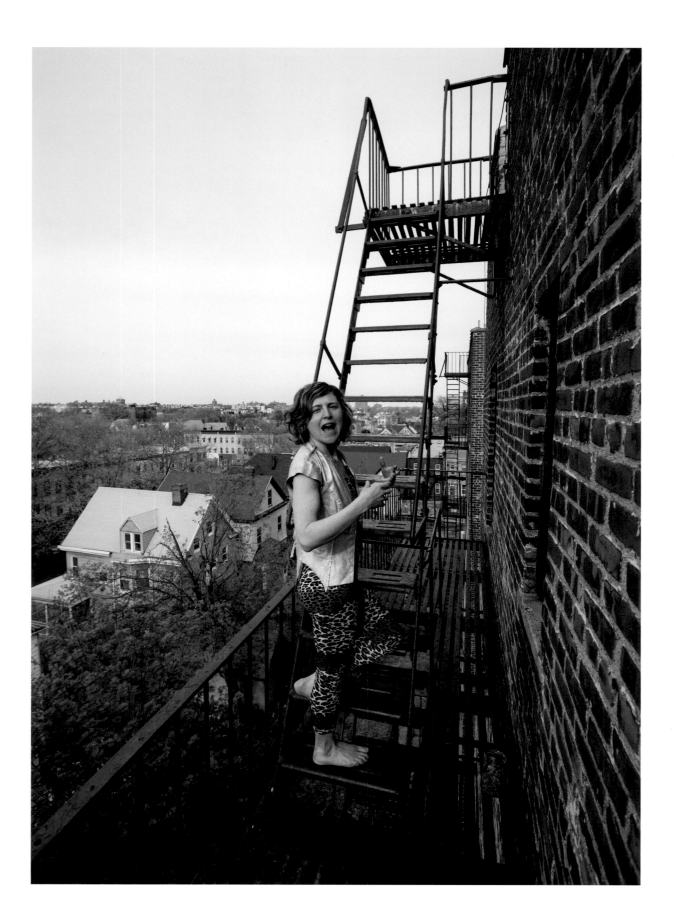

Mirah Zeitlyn, renowned singer
Brooklyn, NY

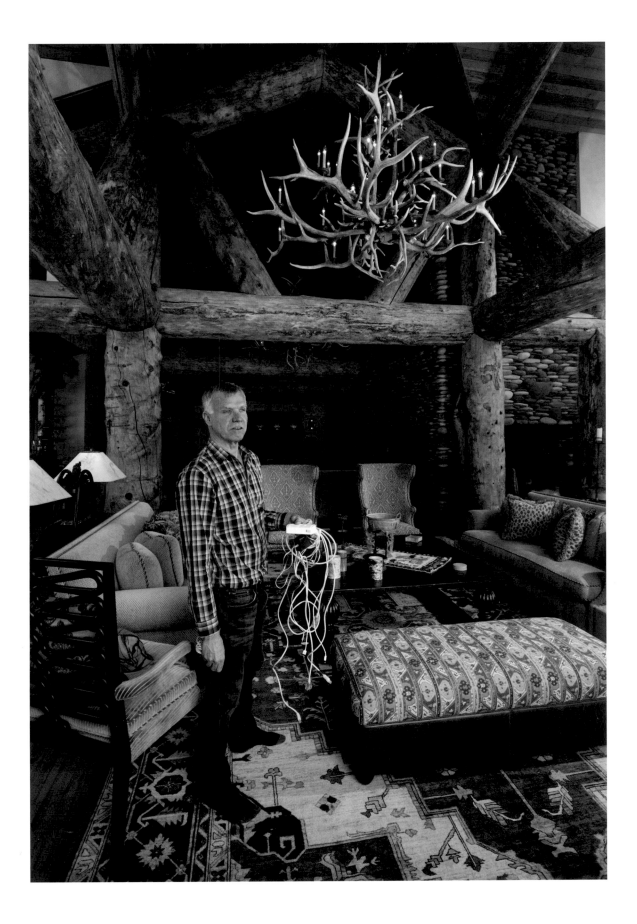

Tim Gill, founder of Quark and philanthropist
Aspen, CO

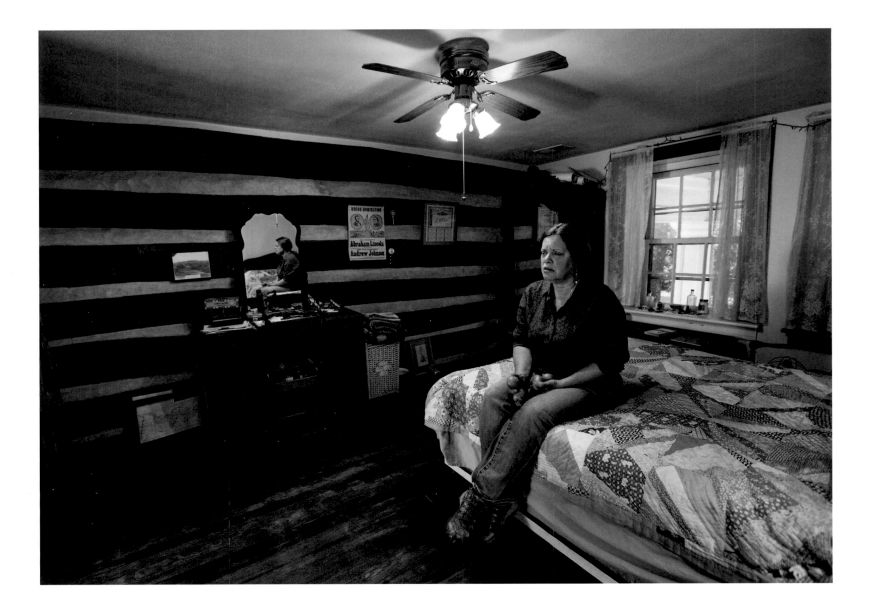

June Hawkins, illustrator and historical plantation operator

Nashville, TN

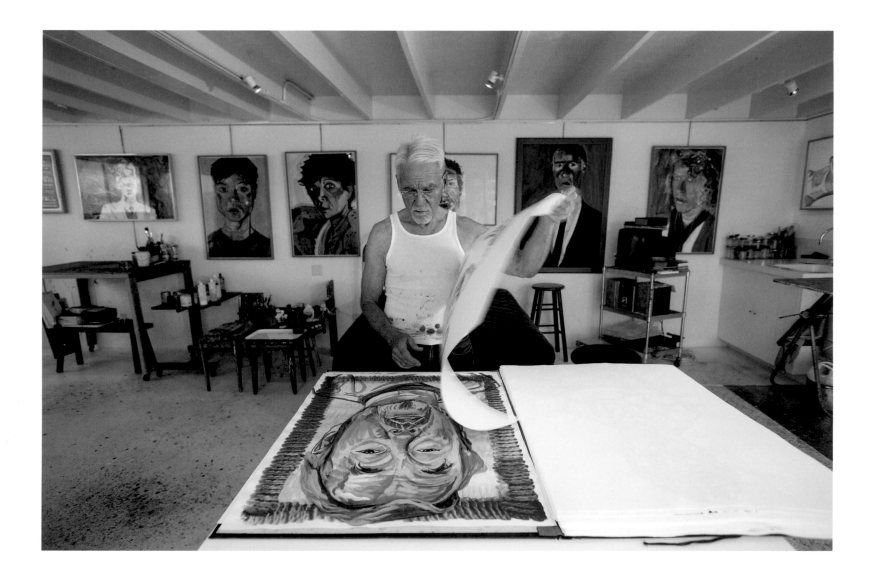

Don Bachardy, artist and former partner of Christopher Isherwood
Santa Monica, CA

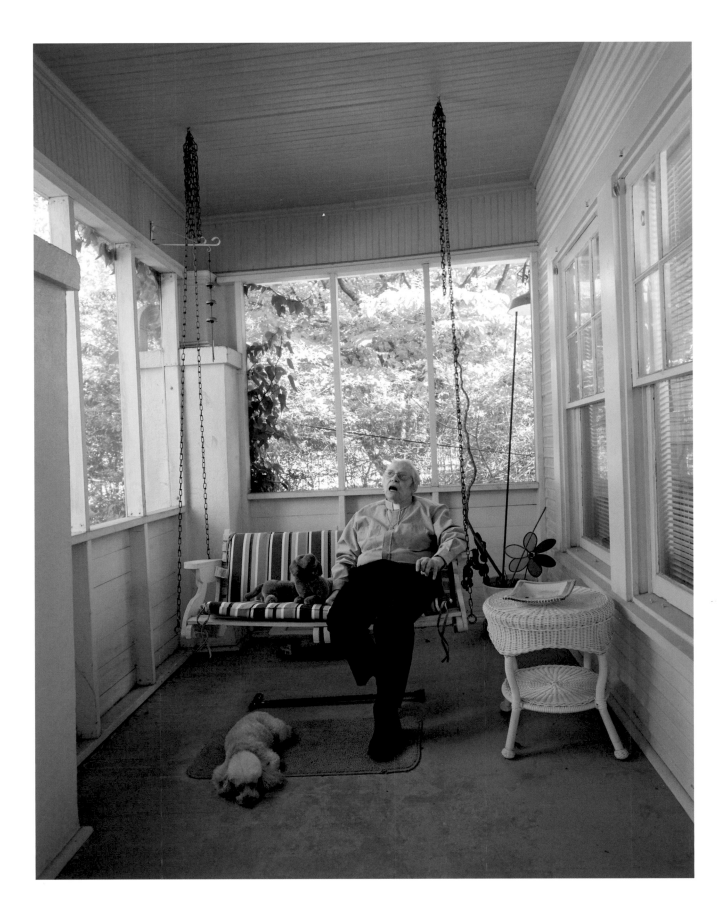

Marge Ragona, reverend

Birmingham, AL

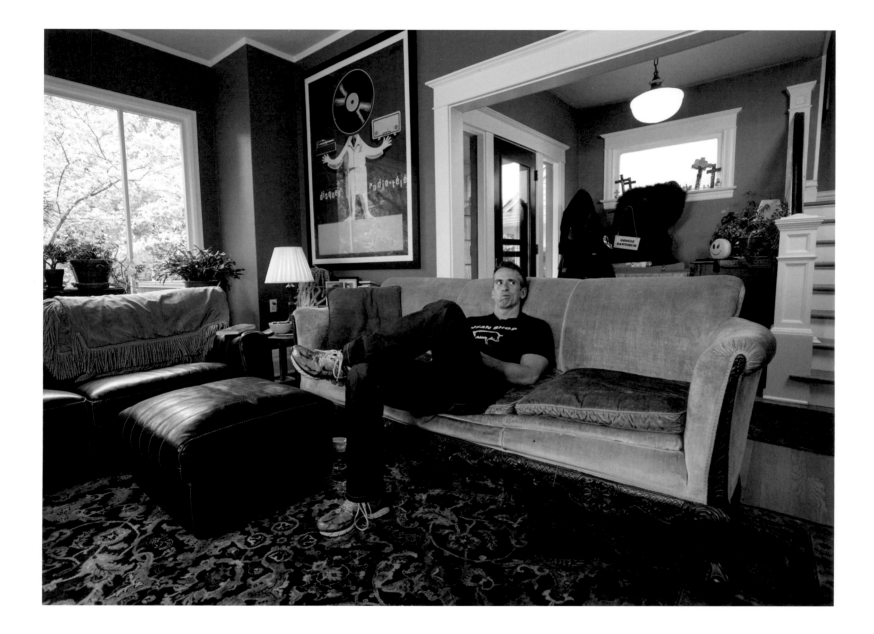

Dan Savage, columnist and media pundit
Seattle, WA

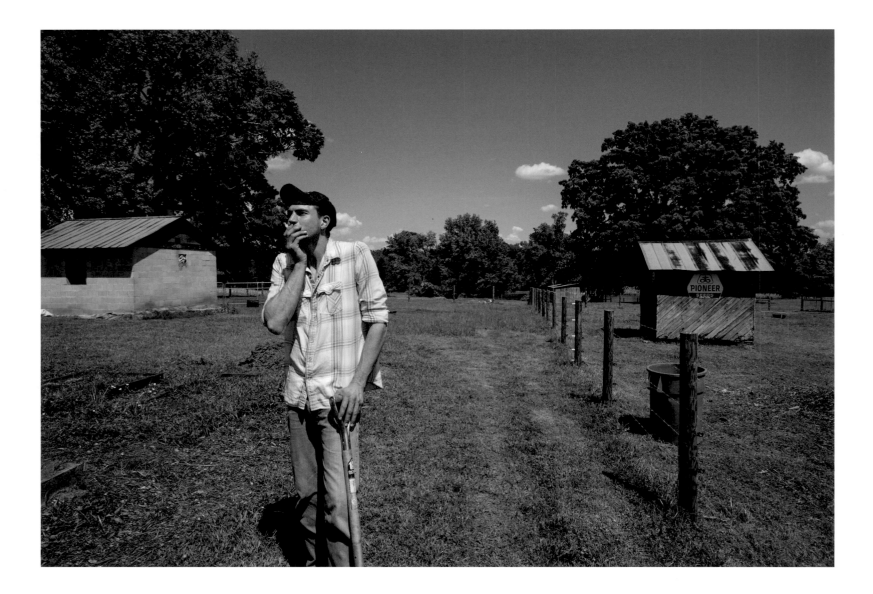

Justin Alexander Wade, farmer
Edgefield, SC

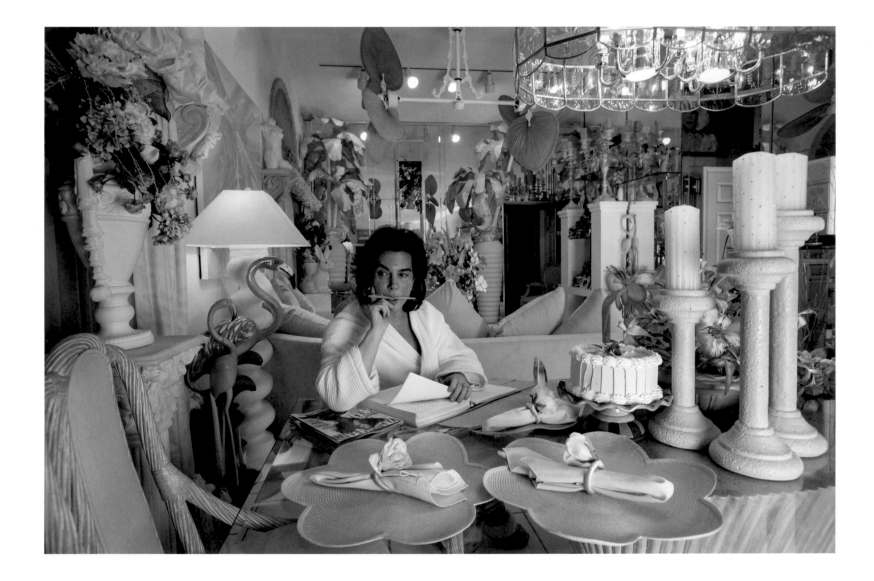

Frank Marino, longest-running headliner on the Strip, dubbed "Ms. Las Vegas"
Las Vegas, NV

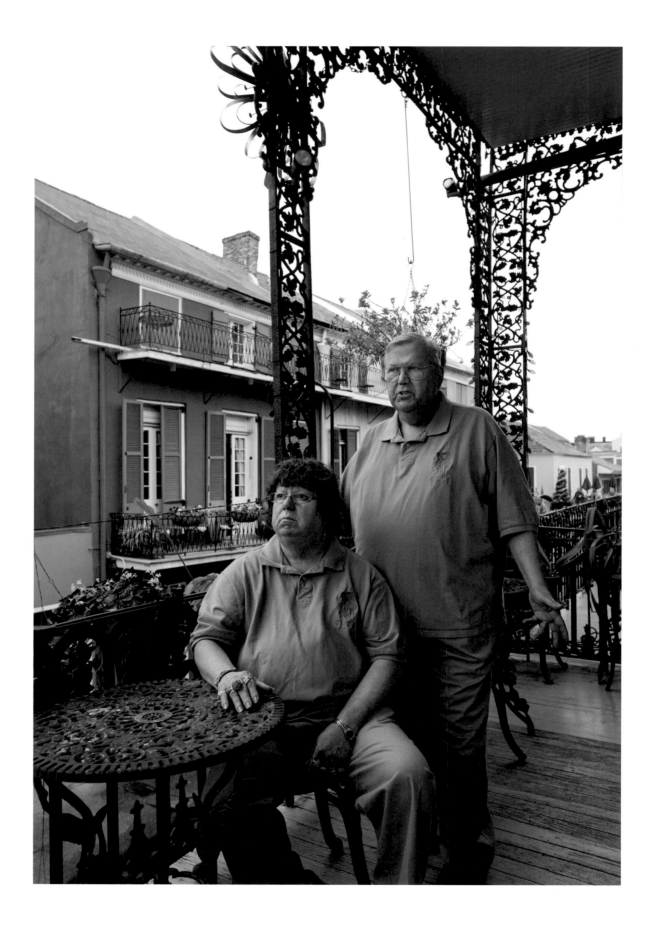

Marsha and **Rip Naquin-Delain**, magazine publishers
New Orleans, LA

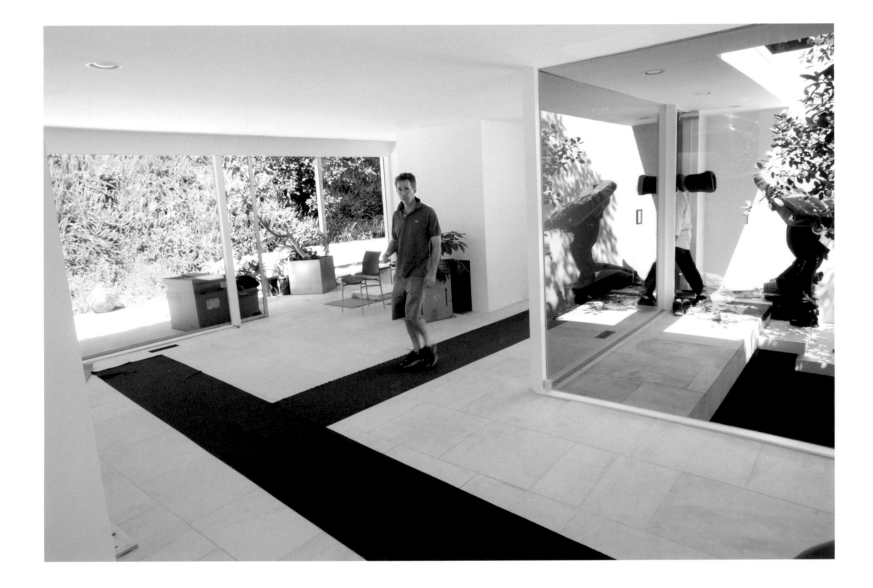

Burt Levitch, attorney
Moving into his Neutra house
Los Angeles, CA

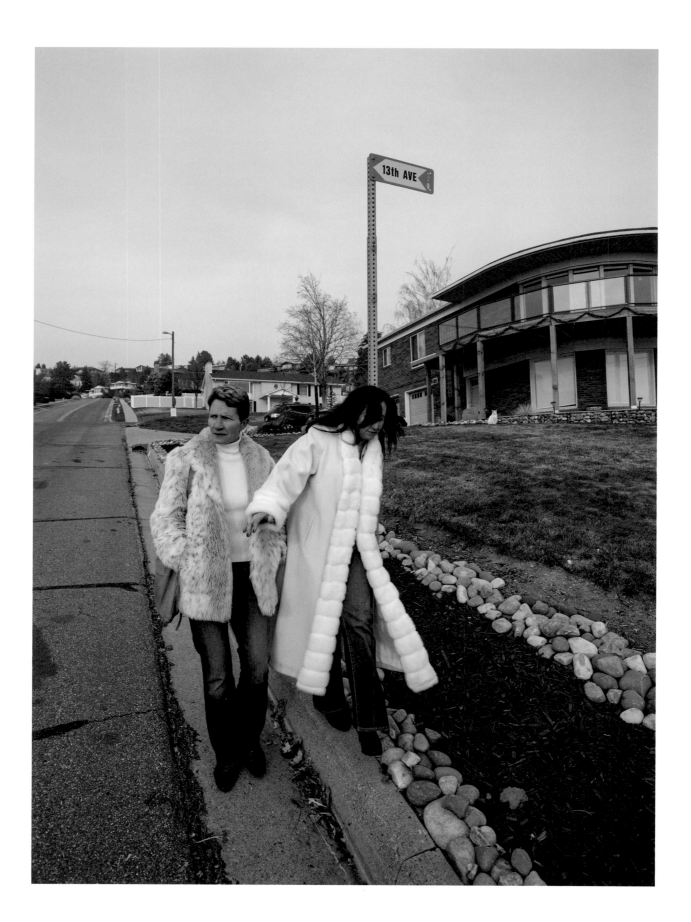

Melanie Hamilton, insurance agent
Robyn Martinez, banker
In front of their house
Salt Lake City, UT

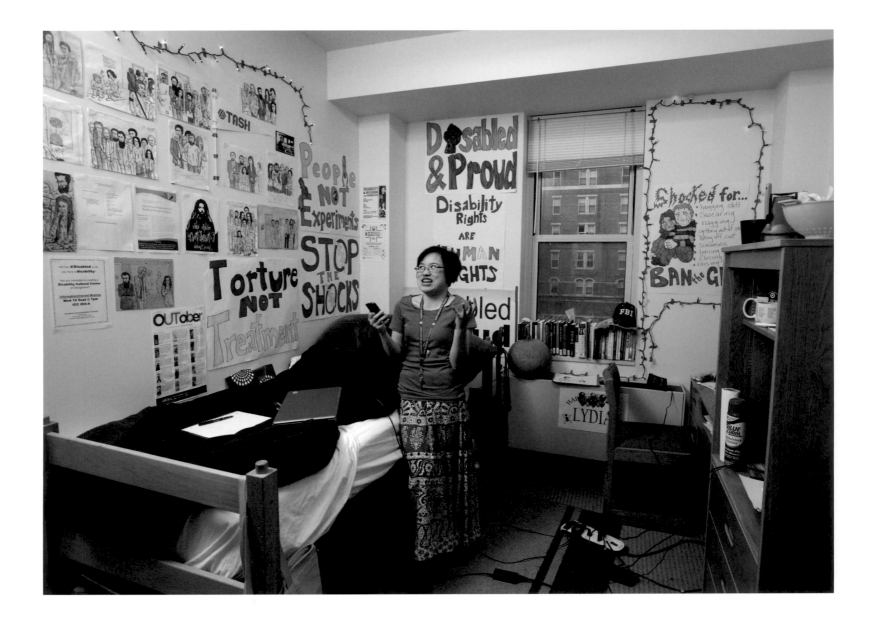

Lydia Brown, Georgetown student and disability activist

Washington, D.C.

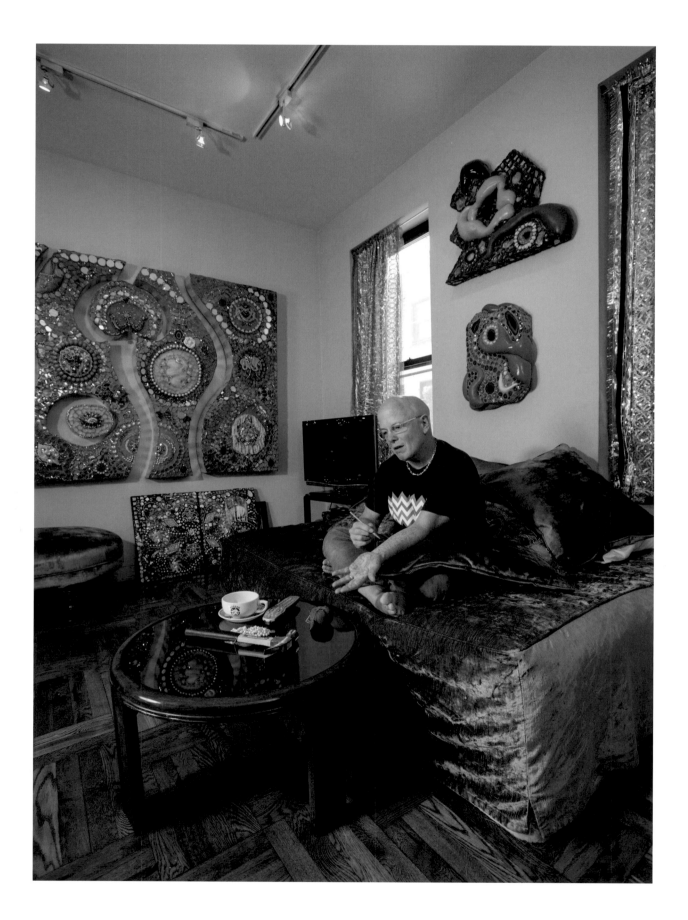

Chris Tanner, sculptor
Writing nctes on his arm
New York, NY

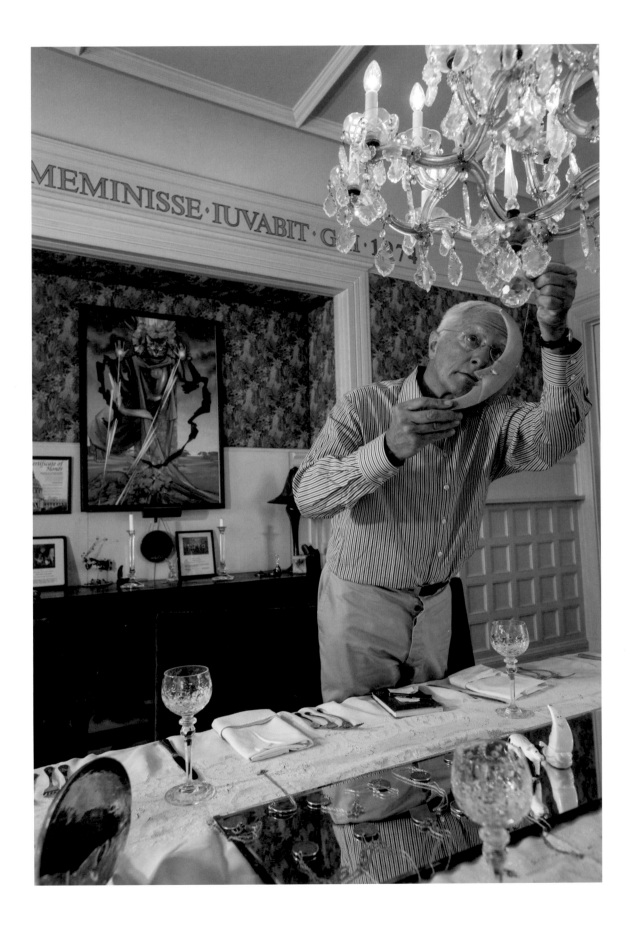

John Newmeyer, epidemiologist

Preparing for a lunar society dinner

San Francisco, CA

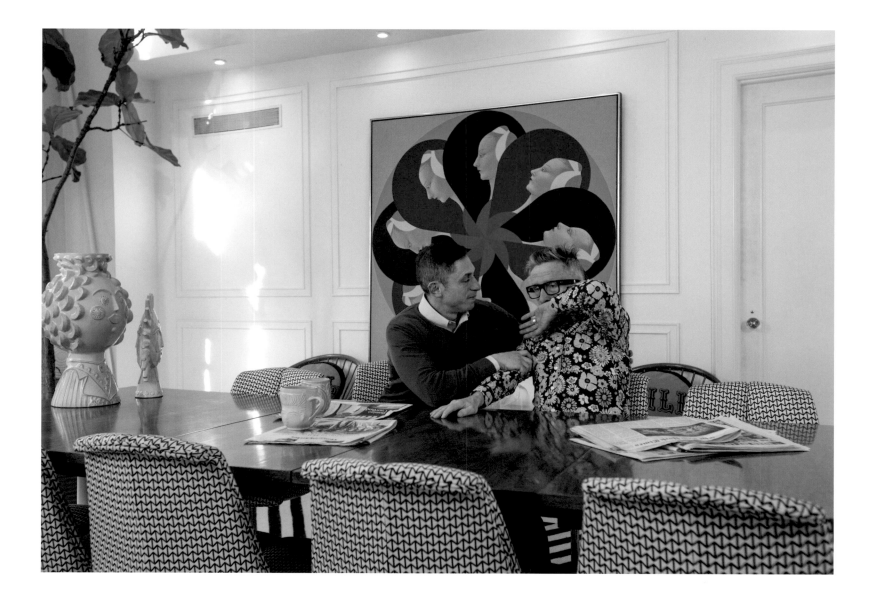

Jonathan Adler, designer and homeware magnate
Simon Doonan, television personality and Barneys NY creative director
New York, NY

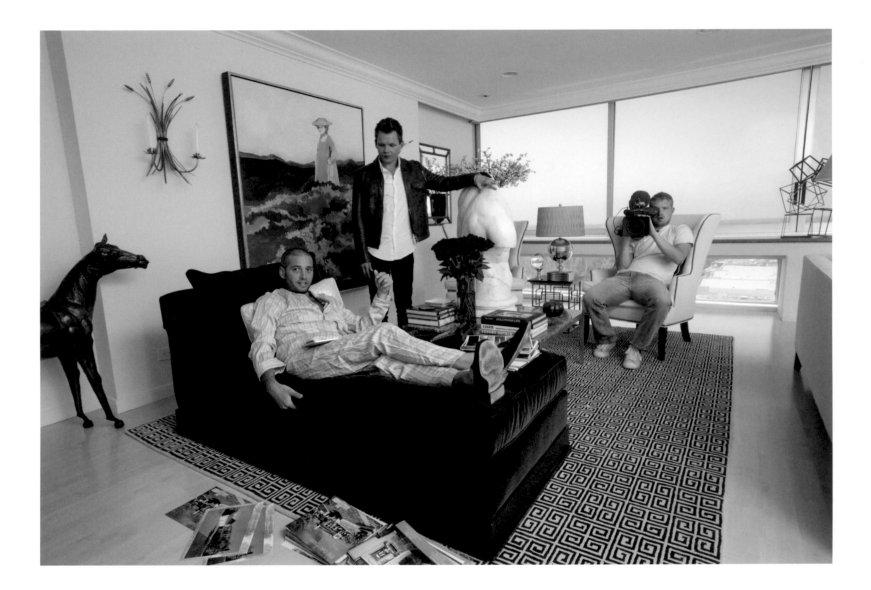

Josh Flagg, star of *Million Dollar Listing*
Colton Thorn, interior designer
Filming us for the show
Los Angeles, CA

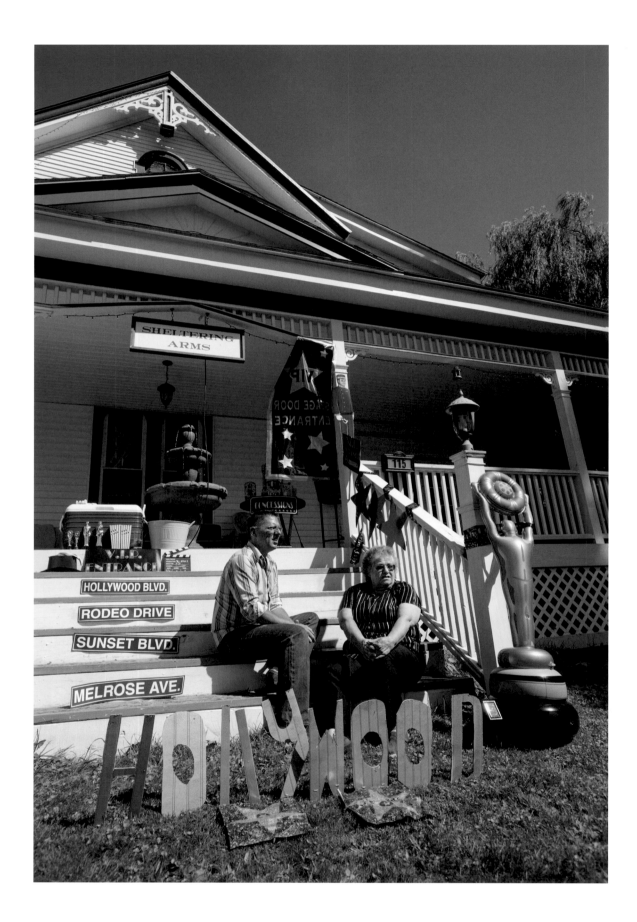

JP Hale, developmental care provider
Cynthia Hale (mother)
Waiting for party guests to arrive
St. Albans, VT

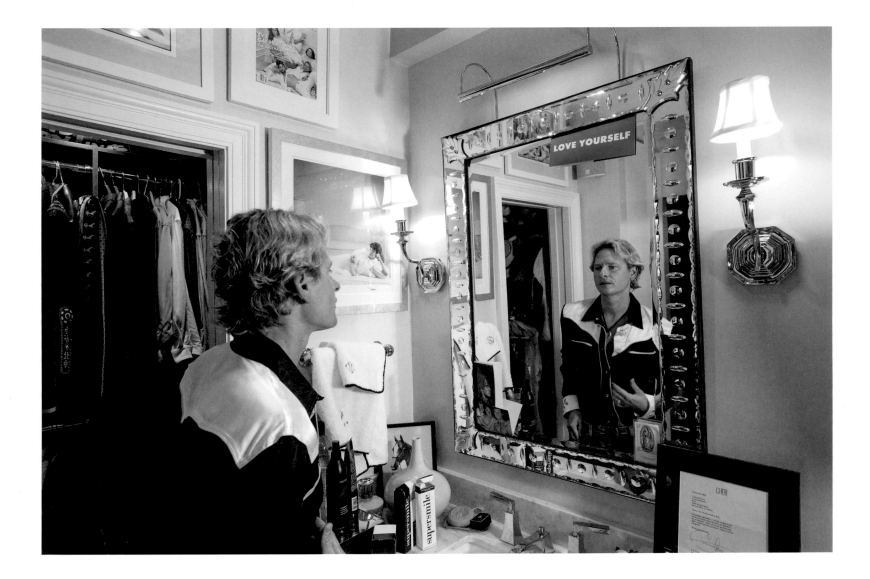

Carson Kressley, Bravo and OWN television host
New York, NY

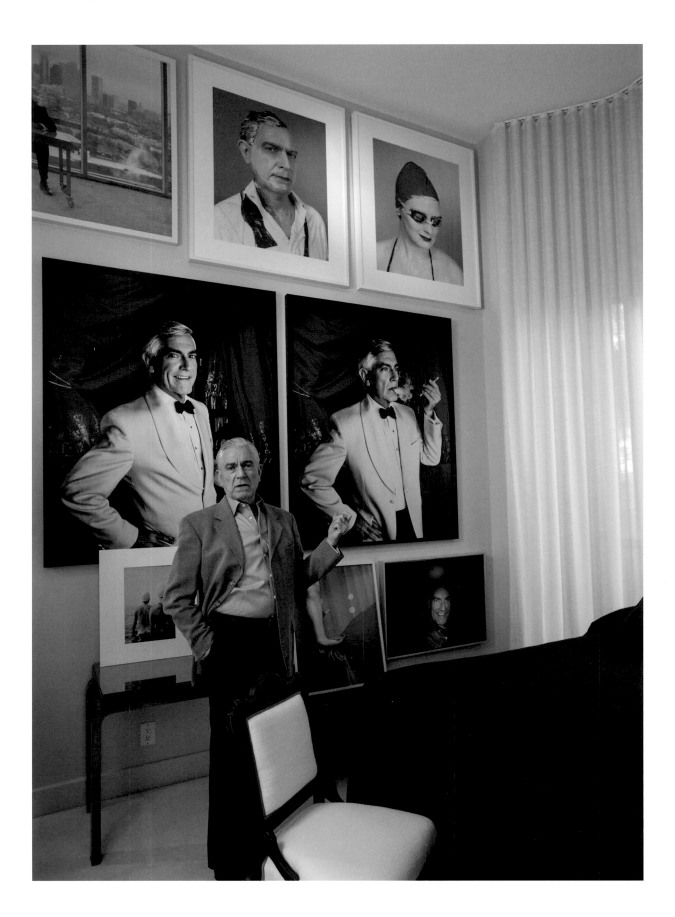

Sir Mark Haukohl, real estate investor

Houston, TX

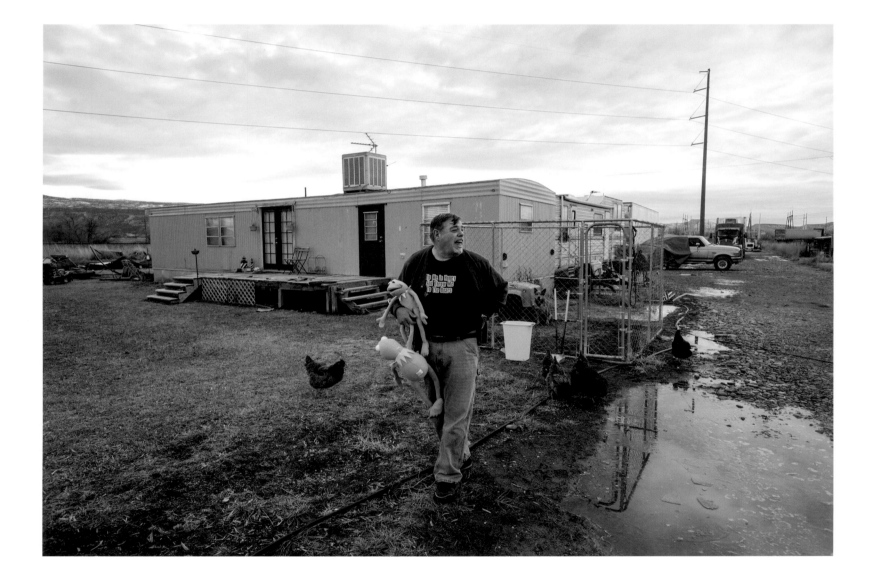

Jerry Shelton, nurse
Fruita, CO

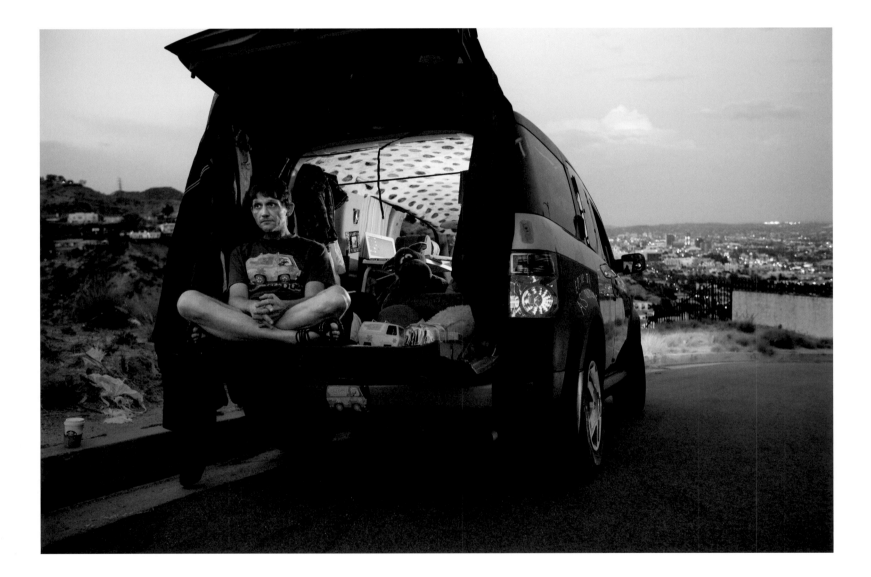

Tim Coulter, homeless activist
Lives in Scooby-Doo themed van
Los Angeles, CA

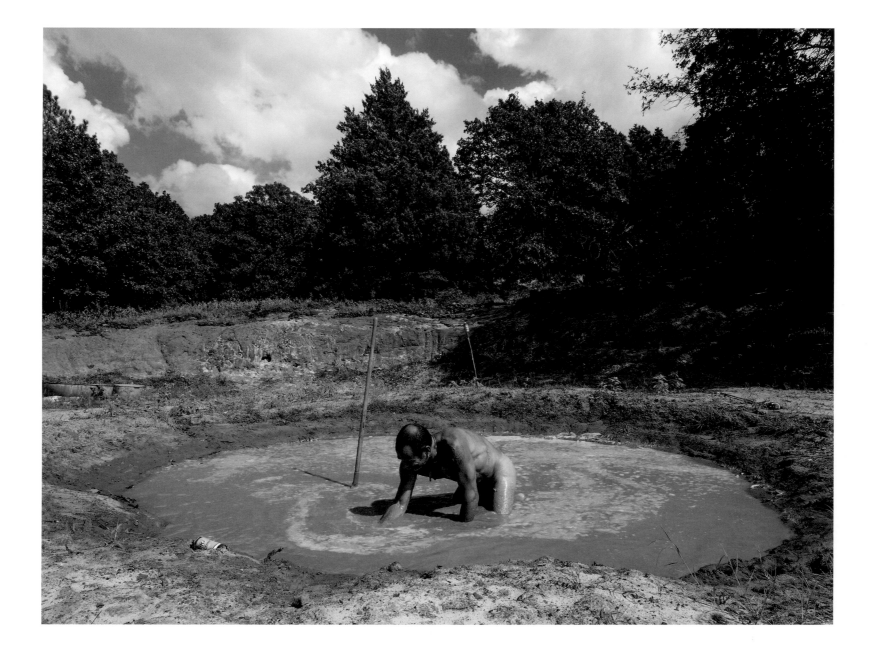

Mitch Pierce, cattle rancher
Cleaning the mud pit in his back yard
Eustace, TX

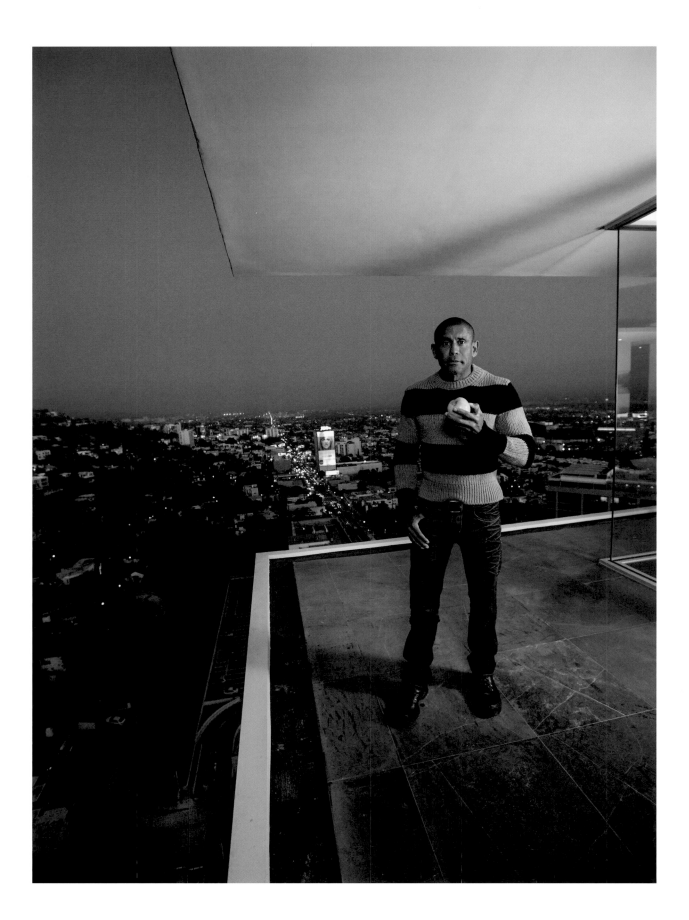

Marc Ware, fashion designer
West Hollywood, CA

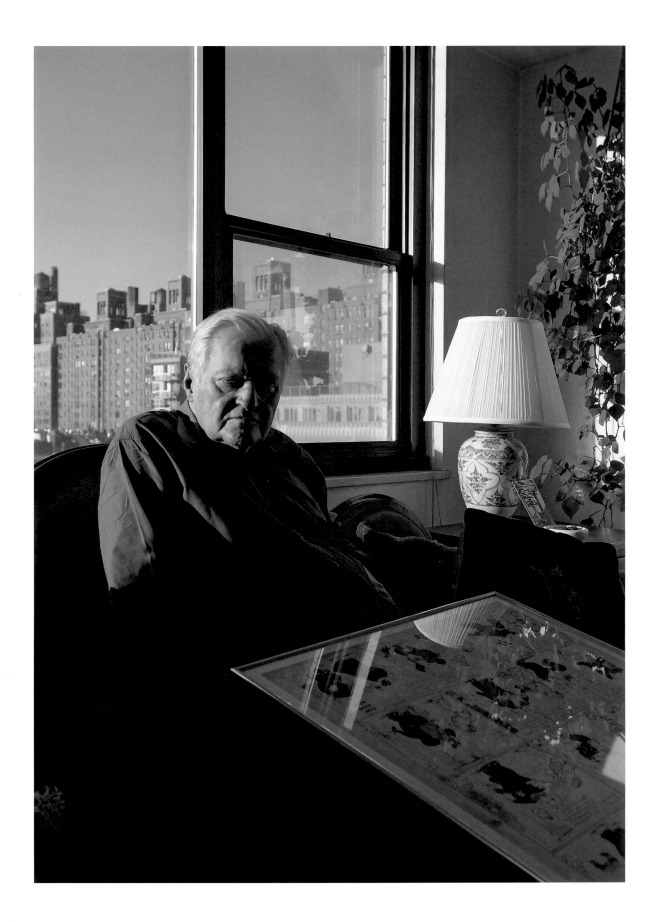

John Ashbery, Pulitzer-winning Poet Laureate of New York
New York, NY

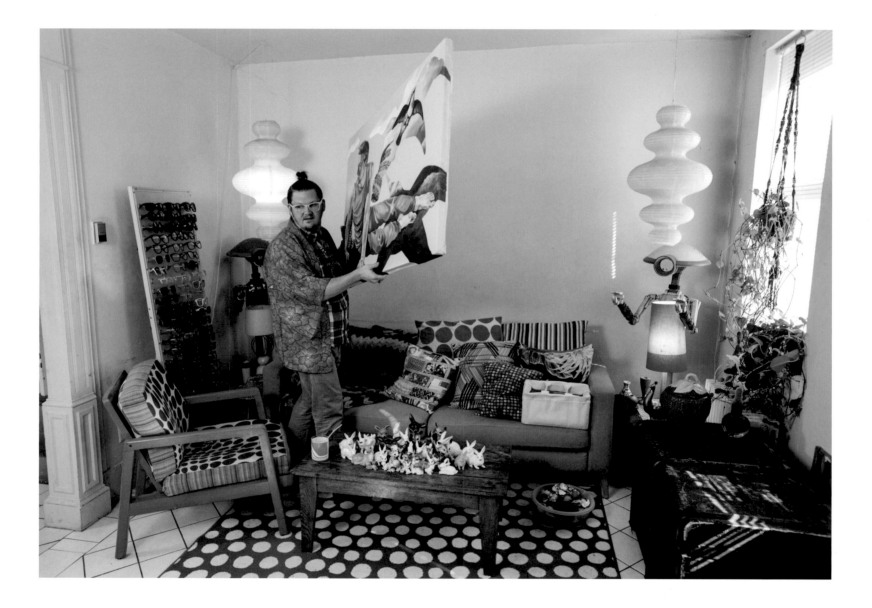

Jay McCarroll, *Project Runway* winner
Philadelphia, PA

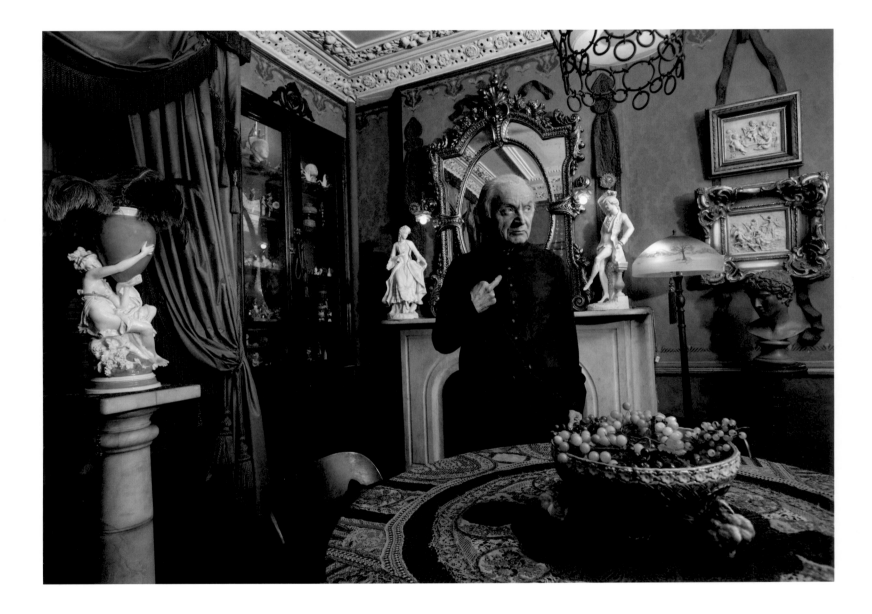

David Lerner, dance essayist
New York, NY

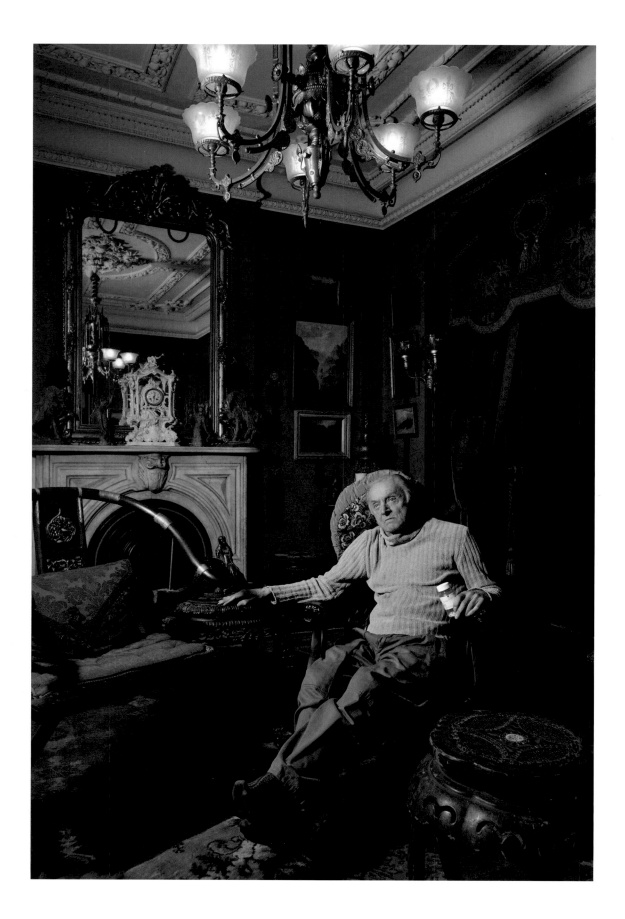

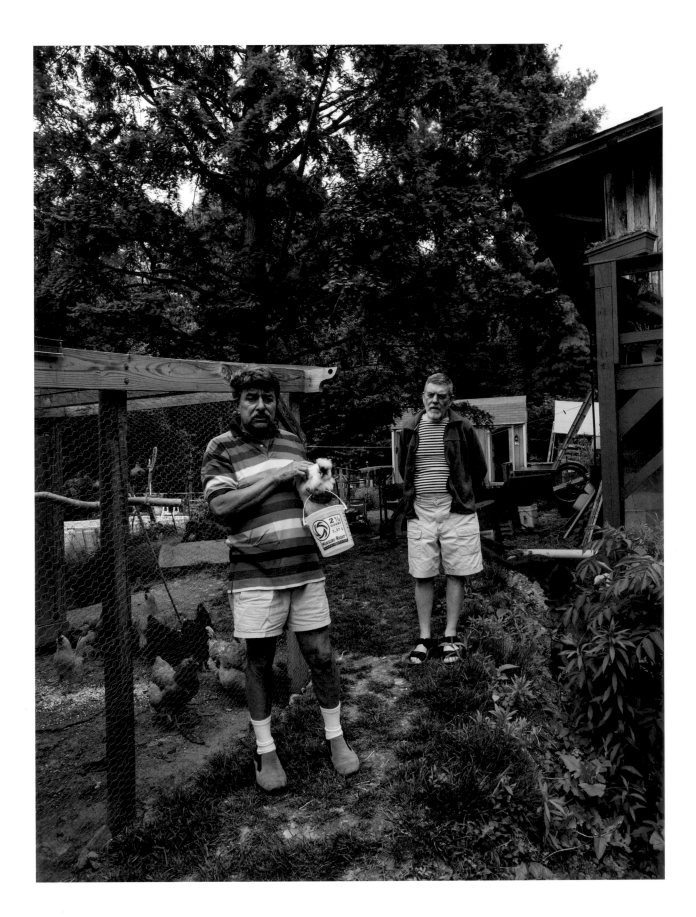

Vick Marchand, ballroom dancing instructor
John Happ, dinosaur paleontologist
Harpers Ferry, WV

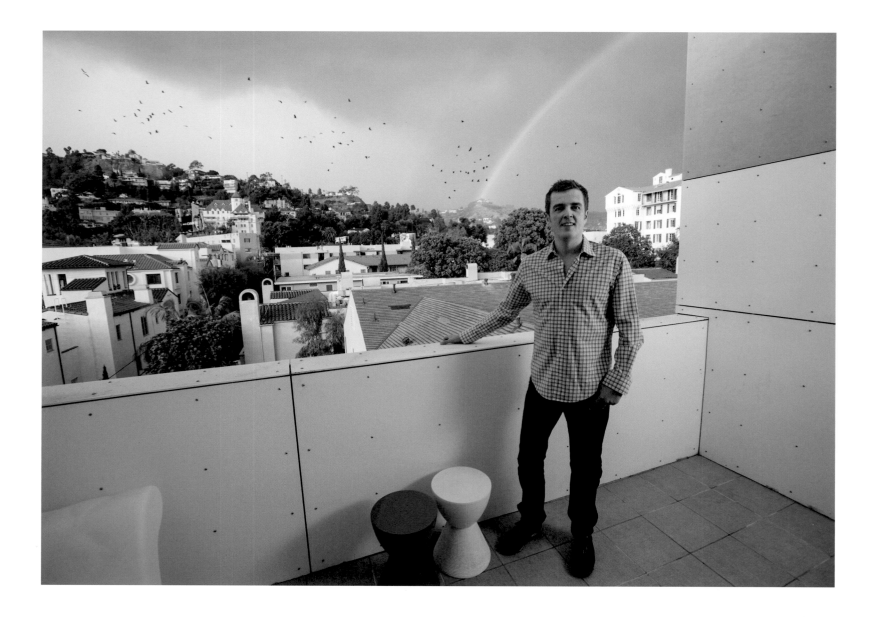

Dmitri Ponomarev, internet entrepreneur
West Hollywood, CA

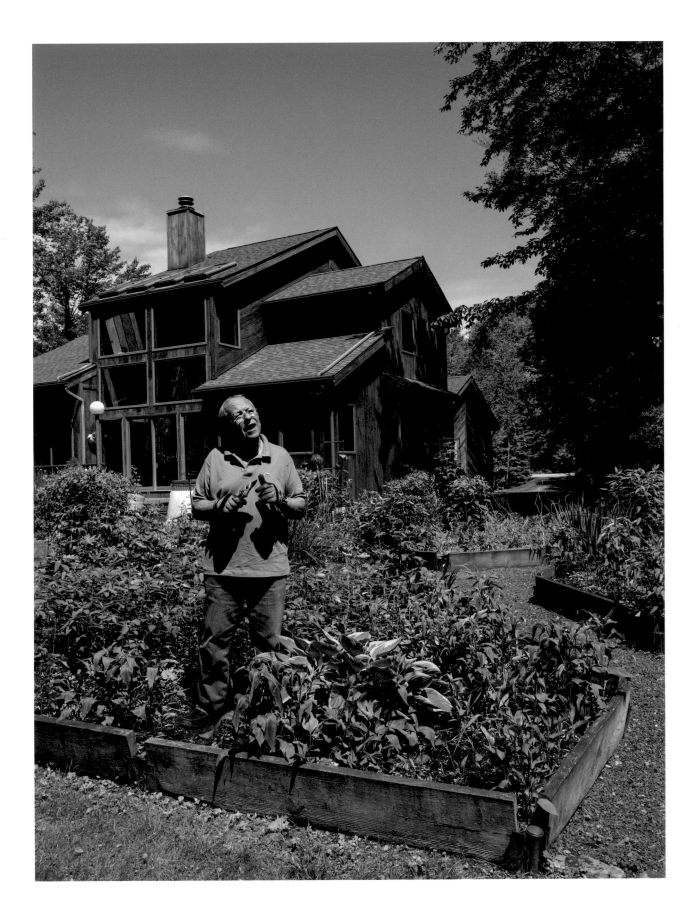

Bishop Gene Robinson, first out gay bishop
Mead, NH

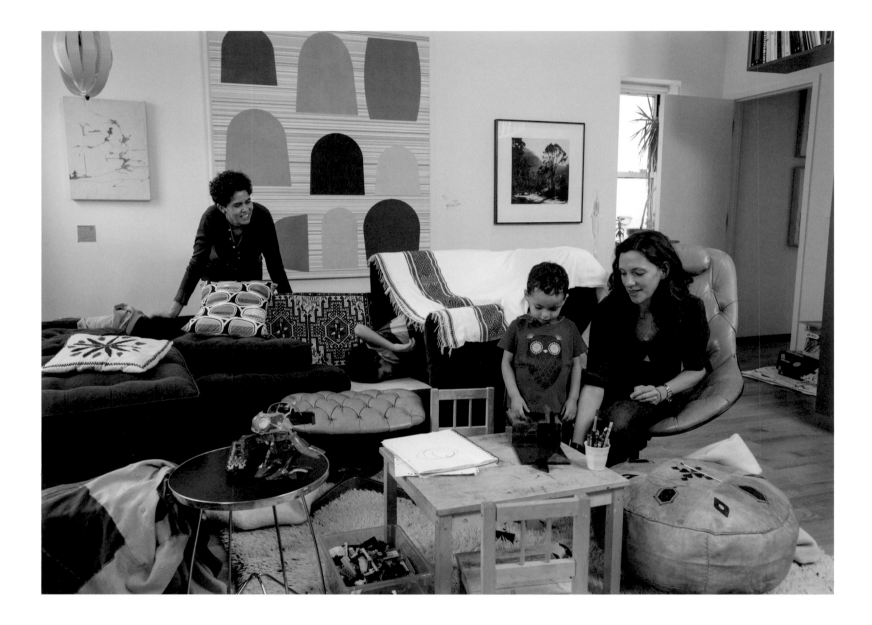

Julie Mehretu and **Jessica Rankin**, renowned artists
New York, NY

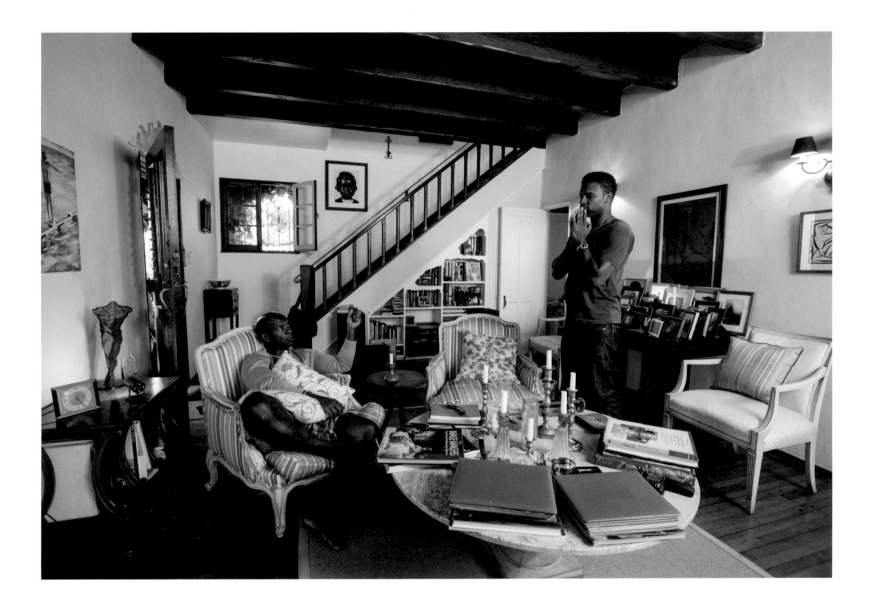

Doug Spearman, actor from *Charmed*, *Star Trek Voyager*, *Noah's Arc*, *Girlfriends*
Marc Anthony Samuel (friend), actor from *Imperfect Sky*, *Avenged*, *Parenthood*
Los Angeles, CA

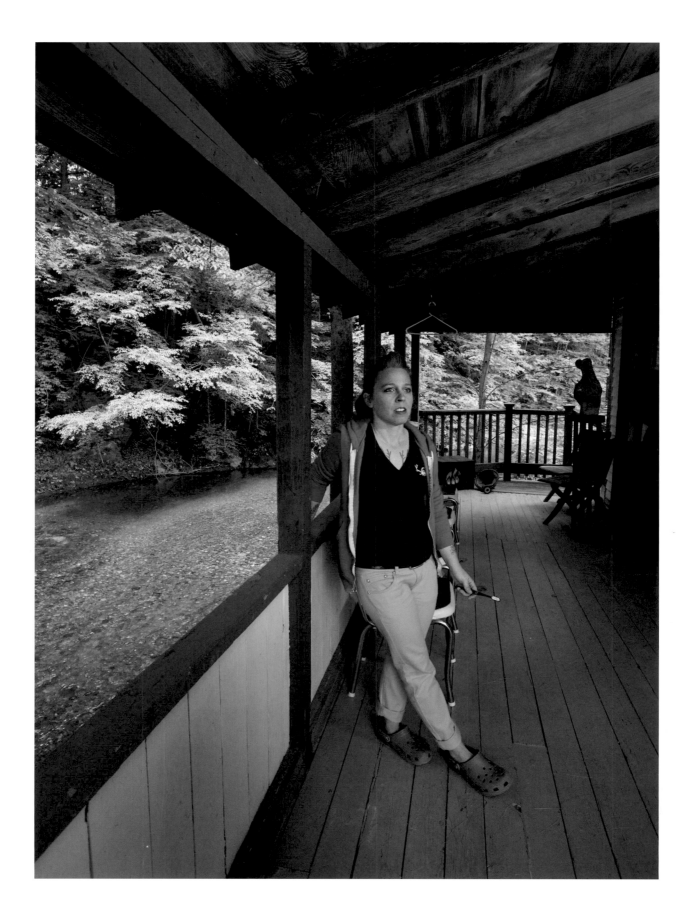

Erin McKeown, award-winning singer
Conway, MA

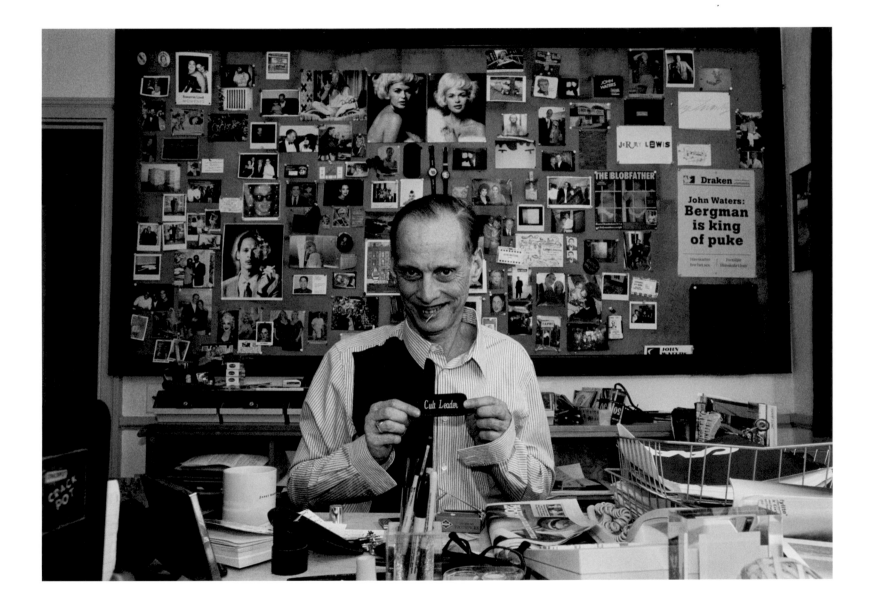

John Waters, director of *Pink Flamingos*, *Polyester*, *Hairspray*, *Pecker*, *Serial Mom*
Baltimore, MD

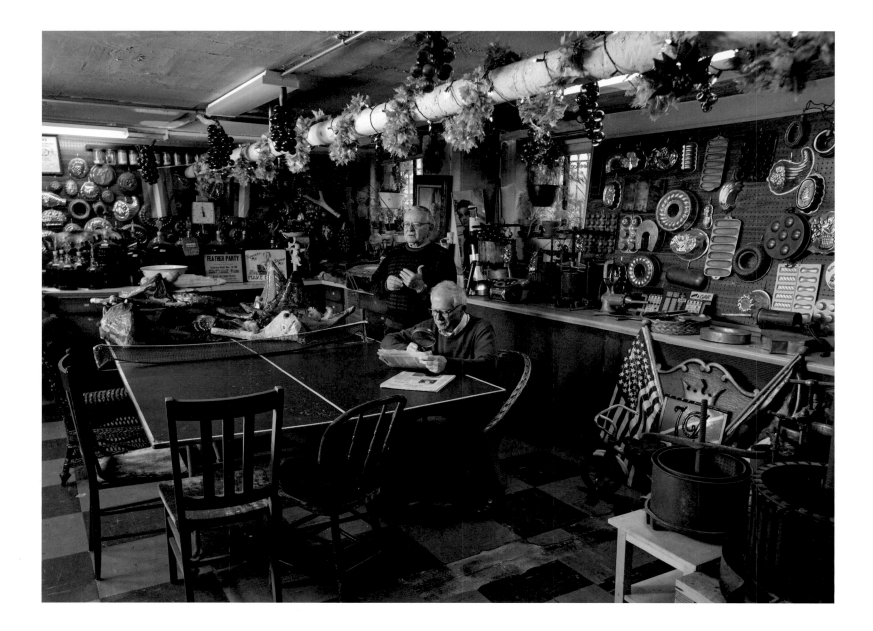

James Darby, US Navy technician
Patrick Bova, librarian
Chicagc, IL

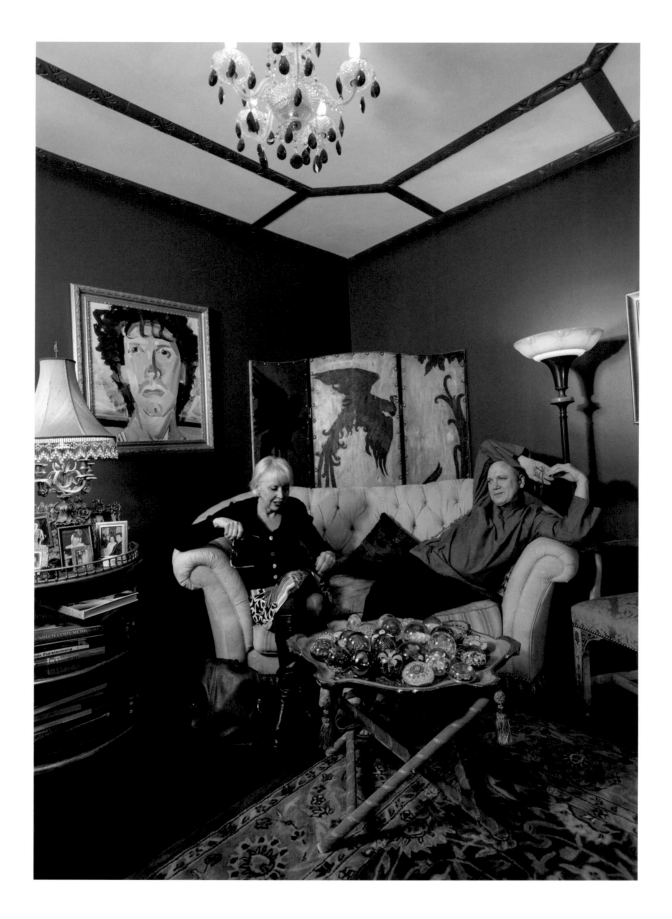

Julie Halston (friend), actress from *Sex and the City*, *Anything Goes*, *Gypsy*
Charles Busch, author of *Tale of the Allergist's Wife*, *Vampire Lesbians of Sodom*
New York, NY

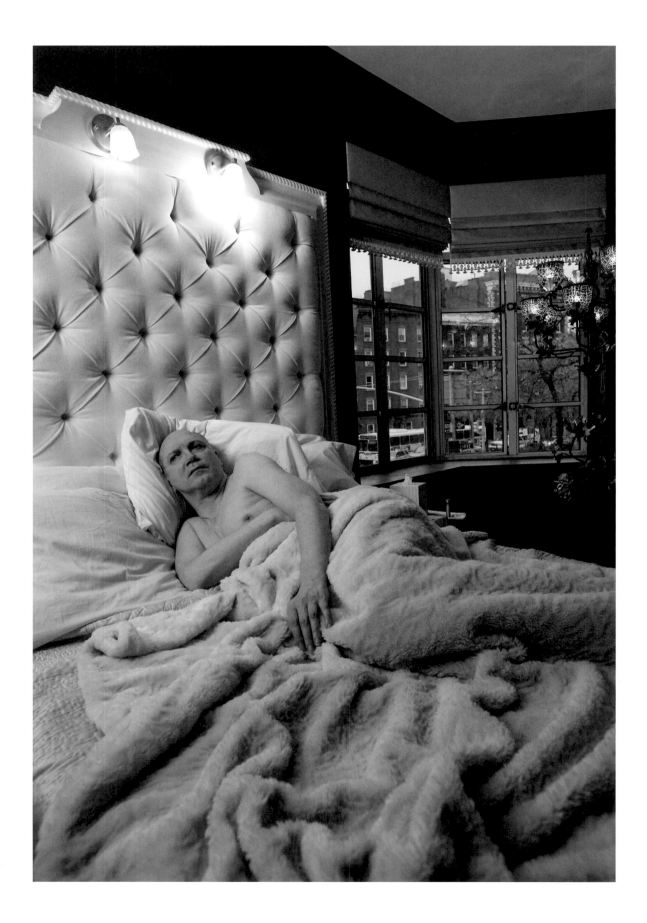

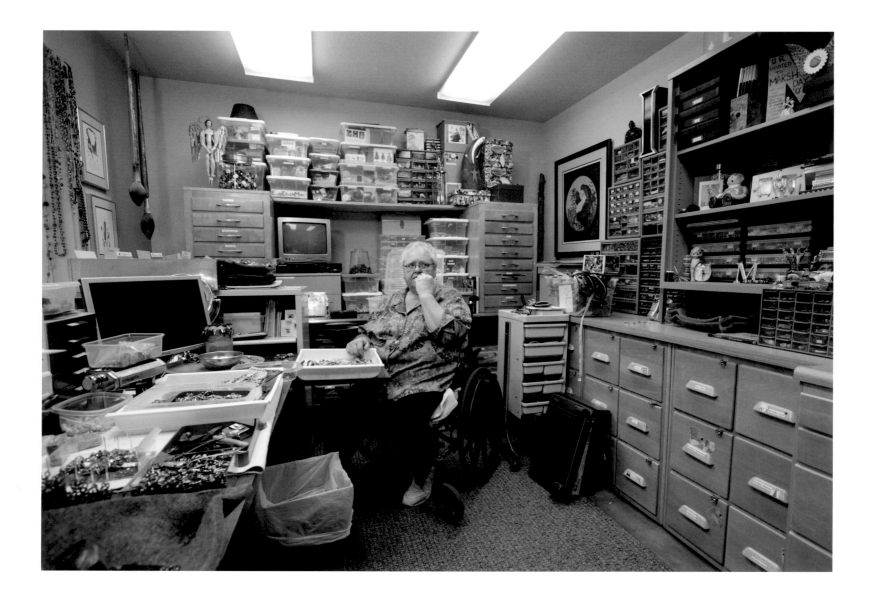

Marsha Provo, billing clerk
Lafayette, IN

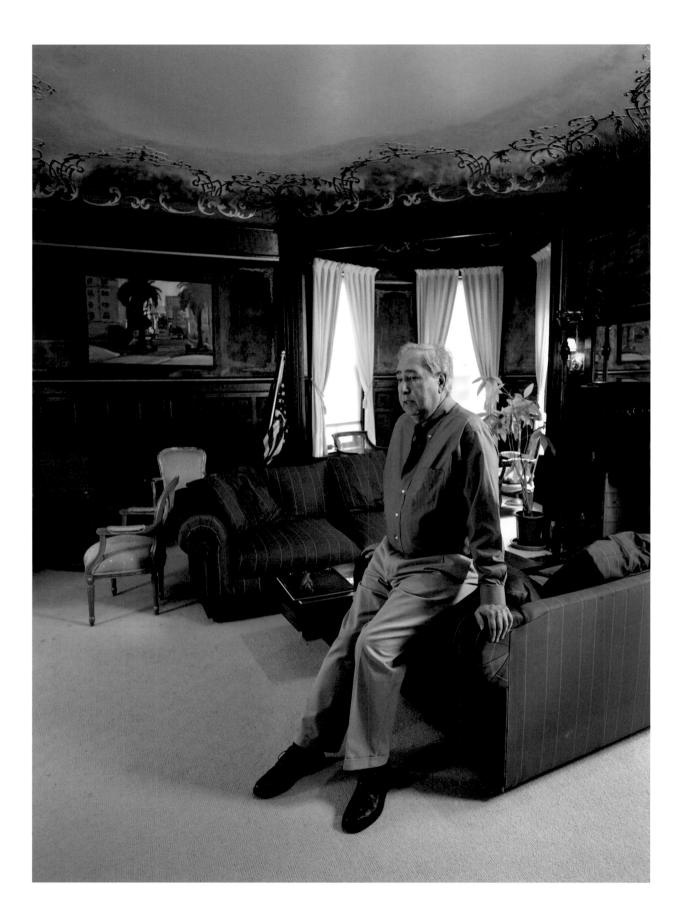

Randolph Delehanty, historian

San Francisco, CA

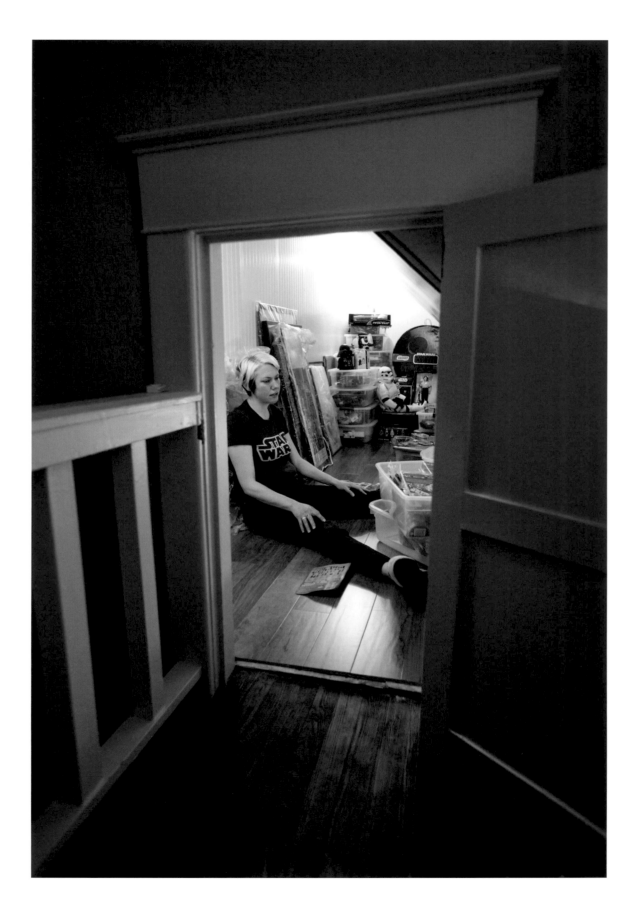

Christine Taylor, employee at Hallmark
Kansas City, MO

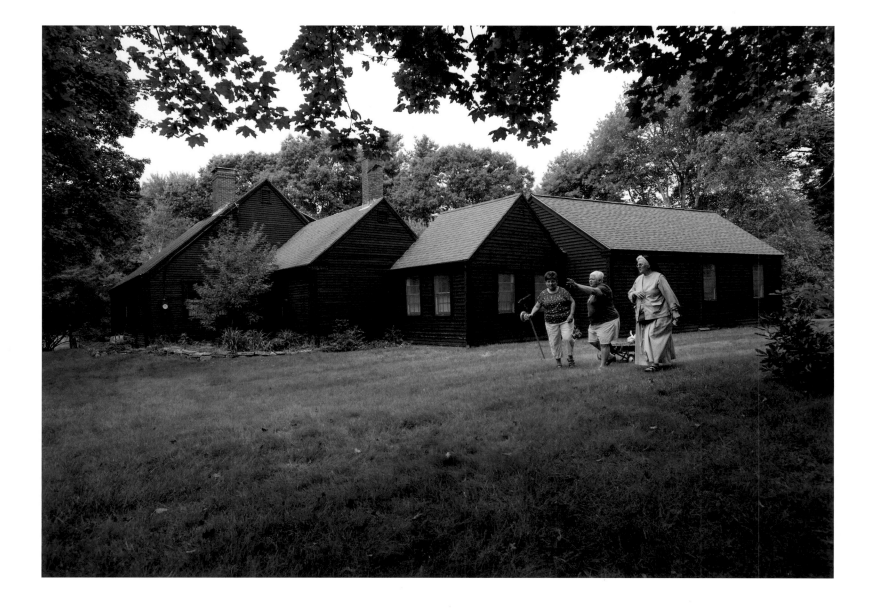

Reverend Rosemary Ananis, bishop
Janet O'Day, nurse
Sister Clare Frances McAvoy (friend)
Wells, ME

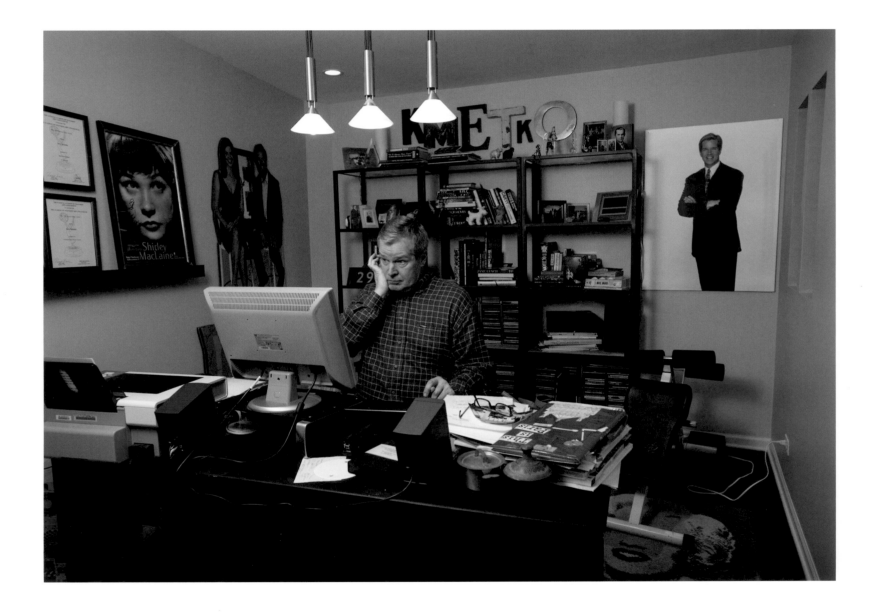

Steve Kmetko, CBS reporter and E! Entertainment anchor

Chicago, IL

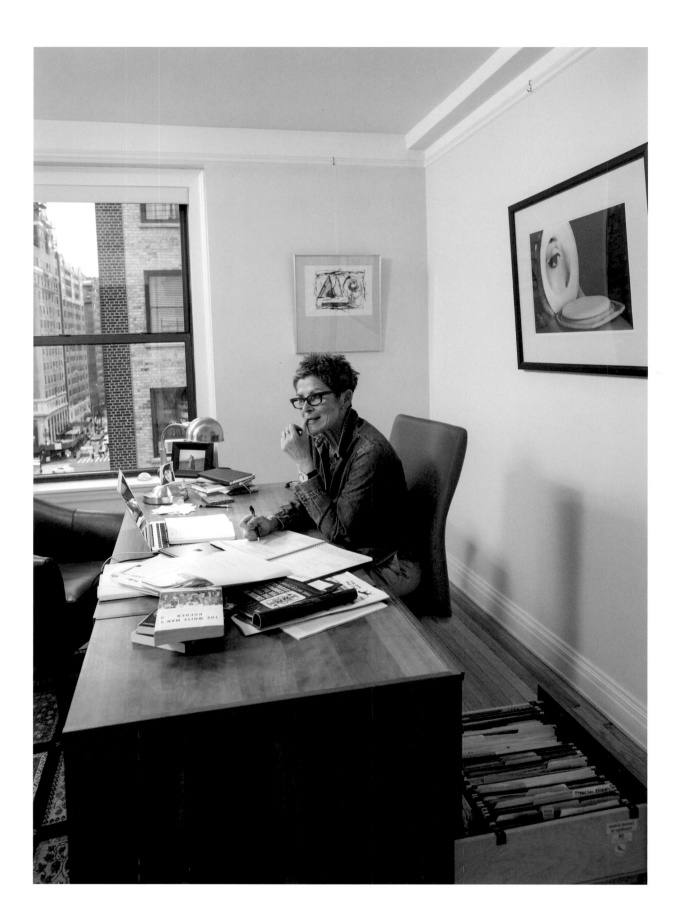

Kate Clinton, comedian and actress from *The L Word*
New York, NY

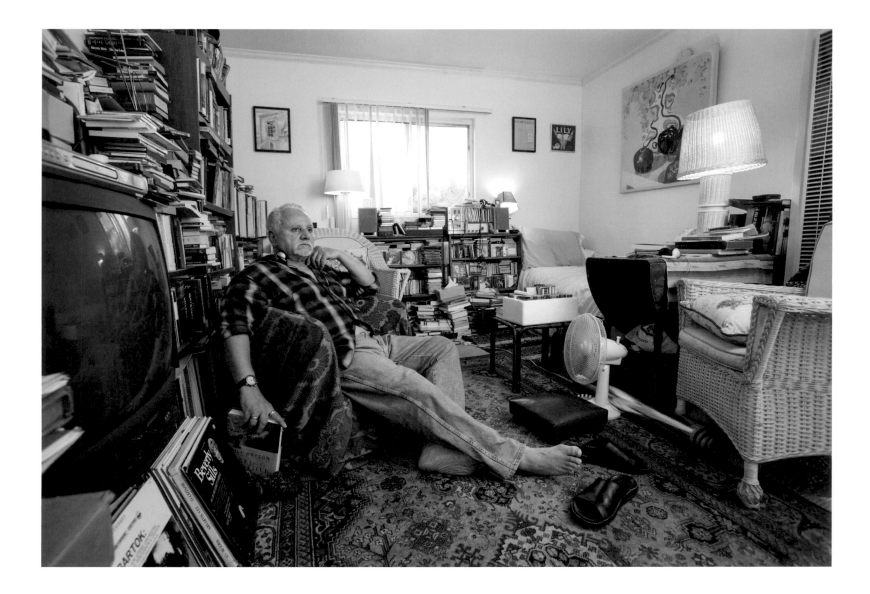

Felice Picano, author of *Nights at Rizzoli*, *Art & Sex in Greenwich Village*
West Hollywood, CA

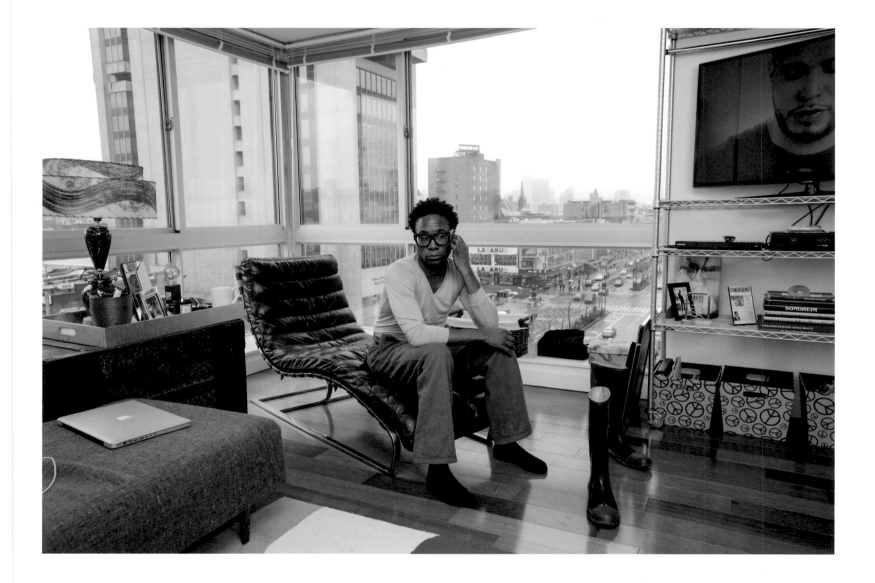

Billy Porter, Tony-winning singer and actor from *Kinky Boots*, *Jesus Christ Superstar*
New York, NY

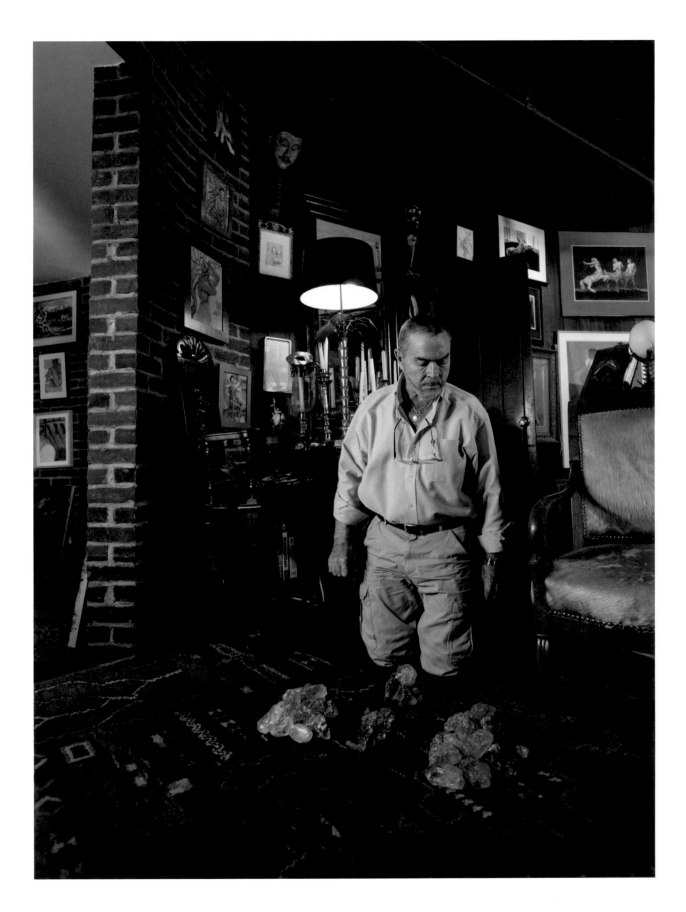

Charles Leslie, director of Leslie-Lohman Museum
New York, NY

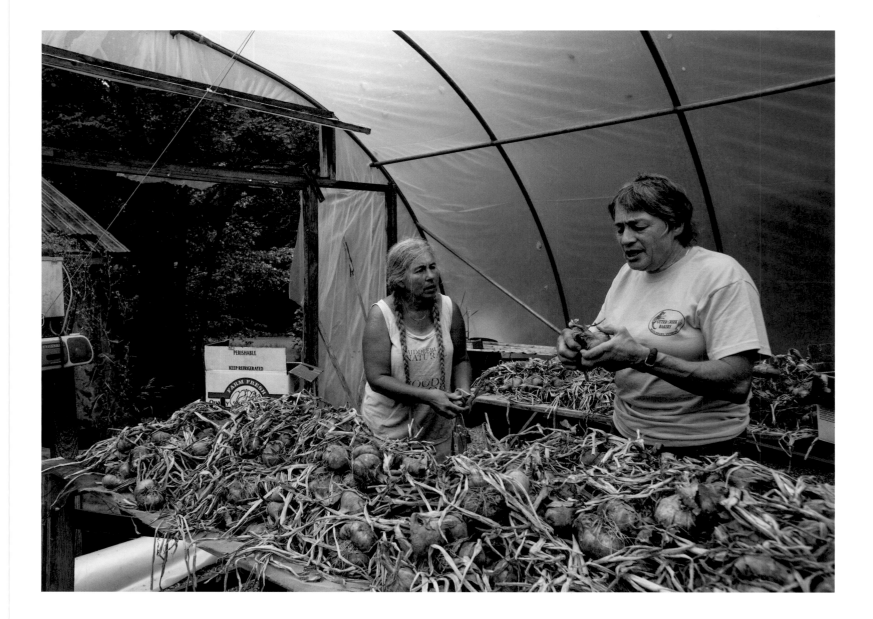

Marjorie Susman and **Marian Pollack**, farmers
New Haven, VT

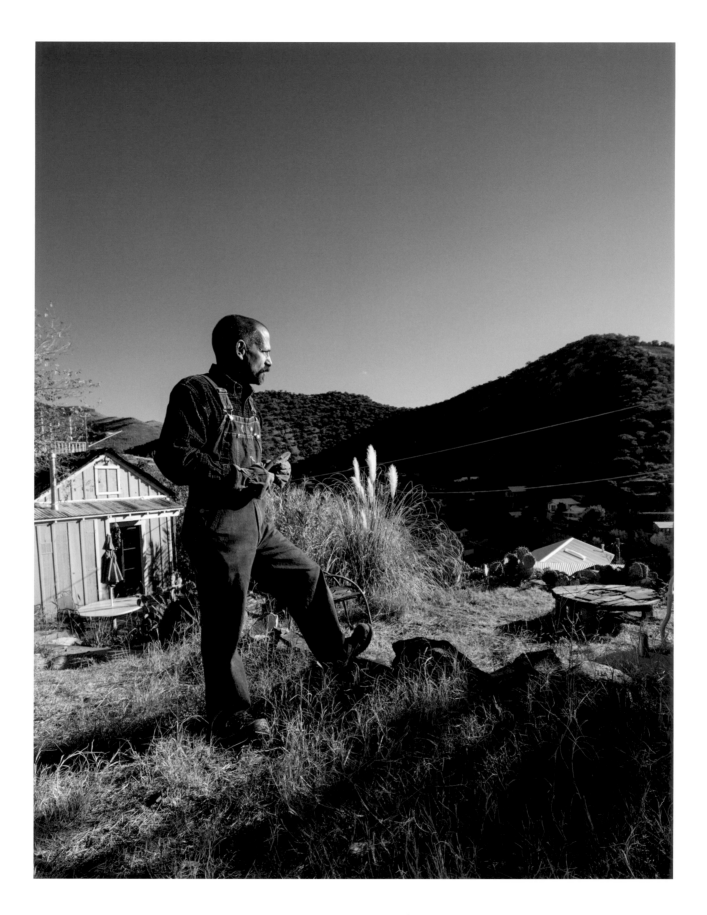

Robert Klein, guest house operator
Bisbee, AZ

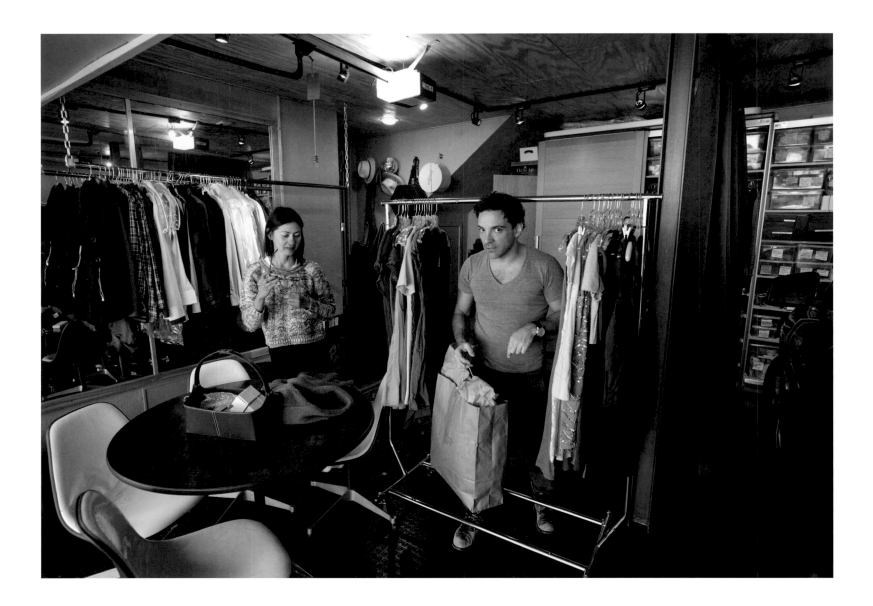

Magda Berliner (friend), fashion designer
George Kotsiopoulos, co-host of *Fashion Police* and correspondent for MSNBC
Los Angeles, CA

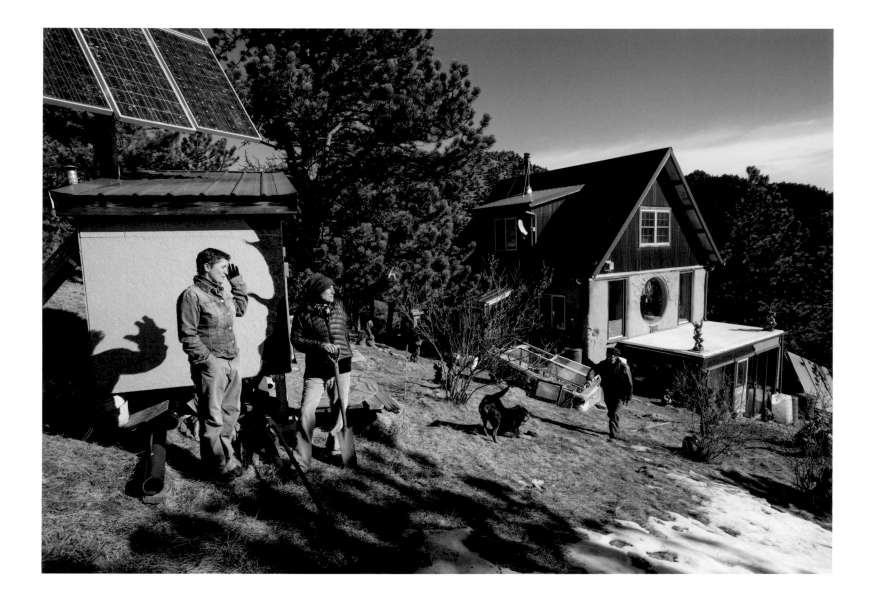

Kim Homer (friend), pizzeria manager
Oak Chezar, women's studies professor
Joy Boston, potter
Living off the grid in a dyke sanctuary
Boulder, CO

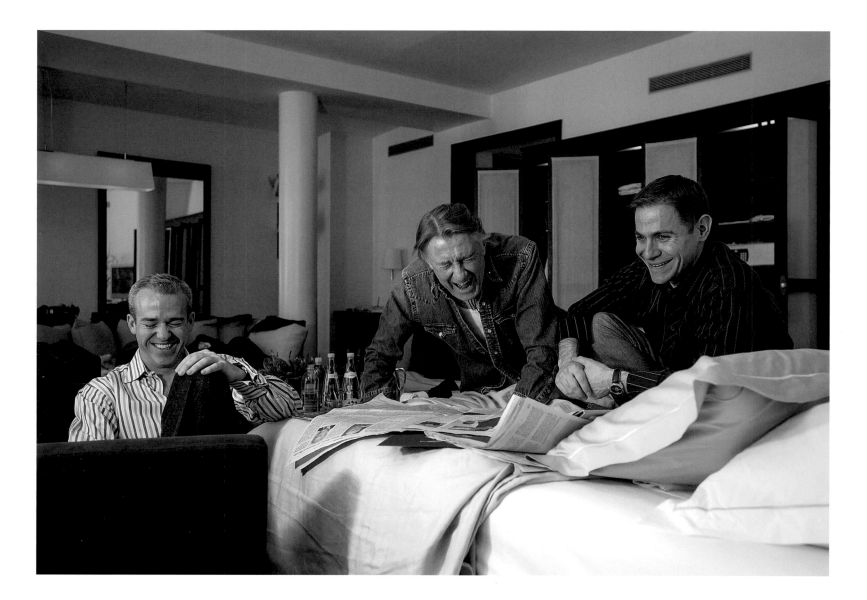

Jess Cagle, editorial director of *People* and *Entertainment Weekly*
Joel Schumacher (friend), director of *Phantom of the Opera*, *St. Elmo's Fire*
Stephen Friedman (friend), MTV executive
New York, NY

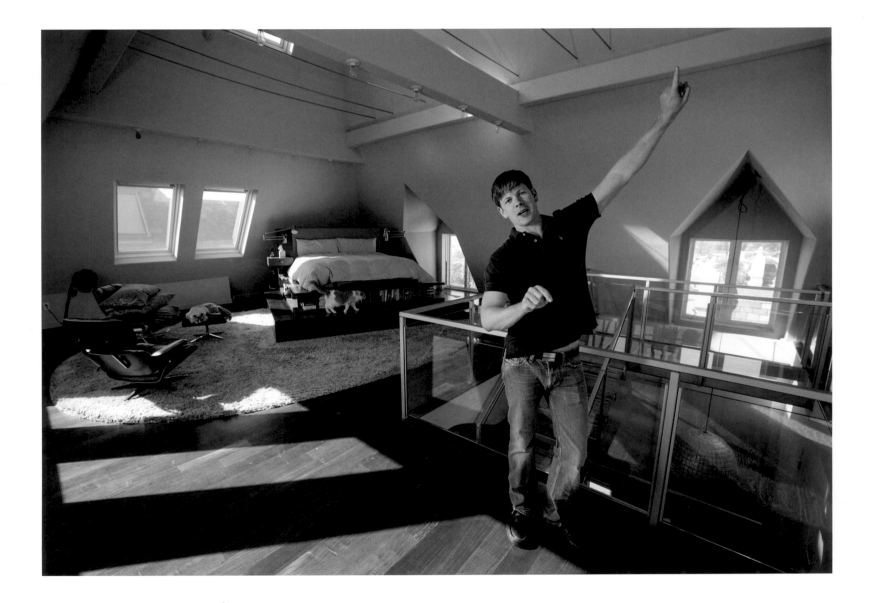

Christopher Rice, author of six bestselling novels and co-host of *The Dinner Party Show*
West Hollywood, CA

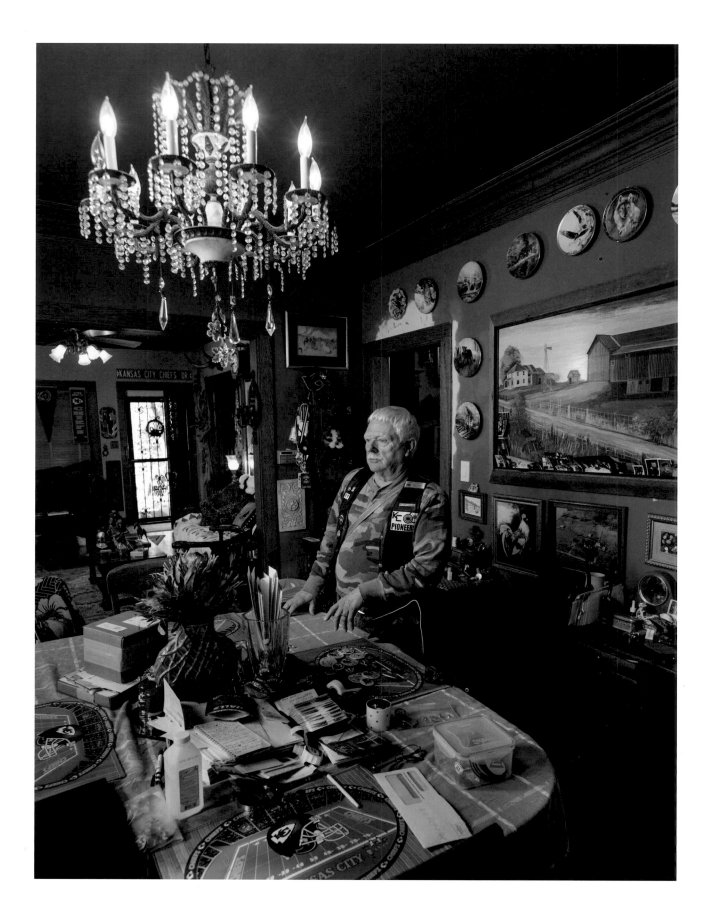

Russ Duncan, manufacturing worker
Kansas City, MO

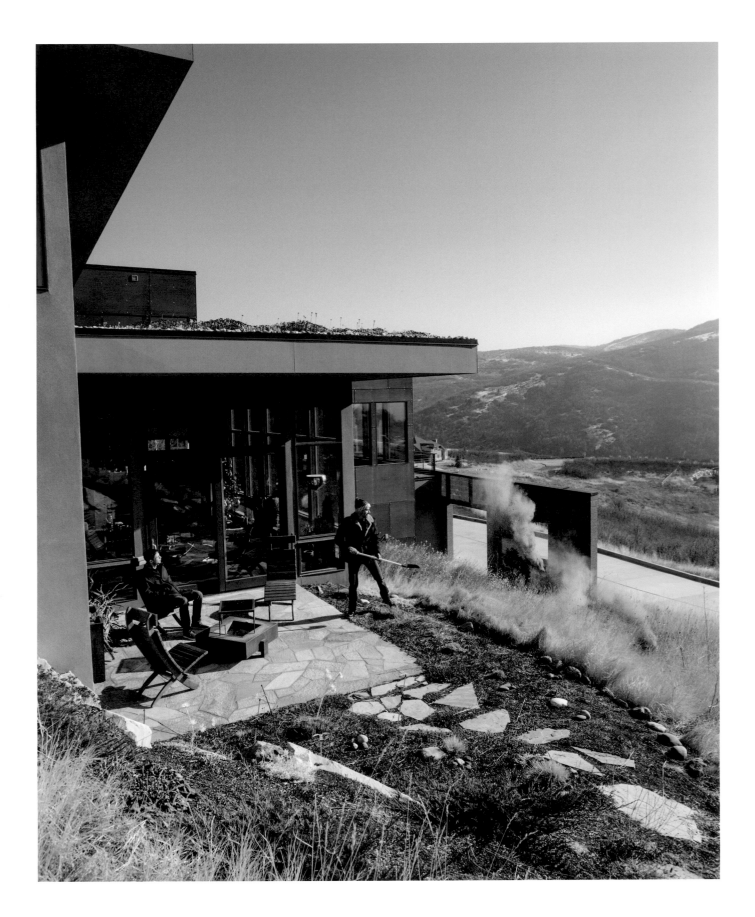

Lee Beckstead, psychologist

Raul Peragallo, anesthesiologist

Emigration Canyon, UT

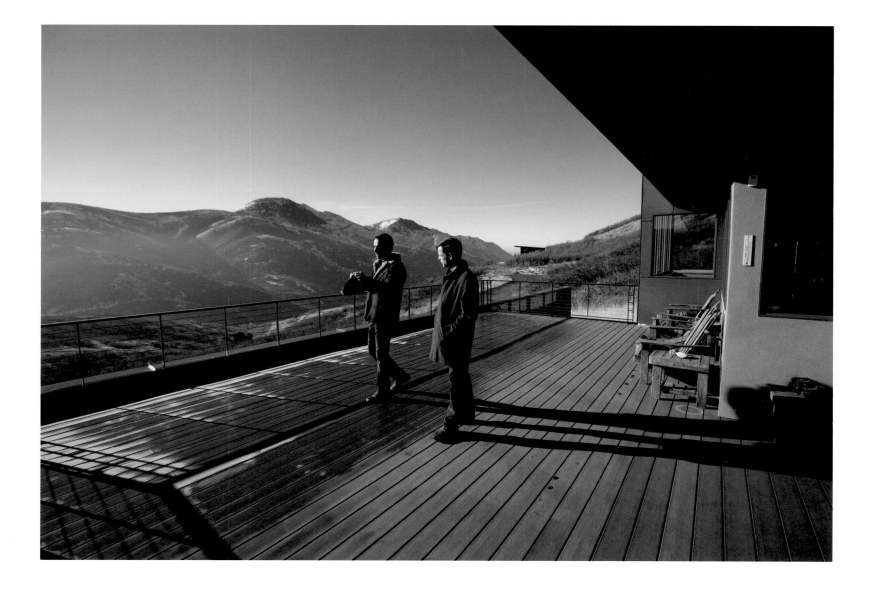

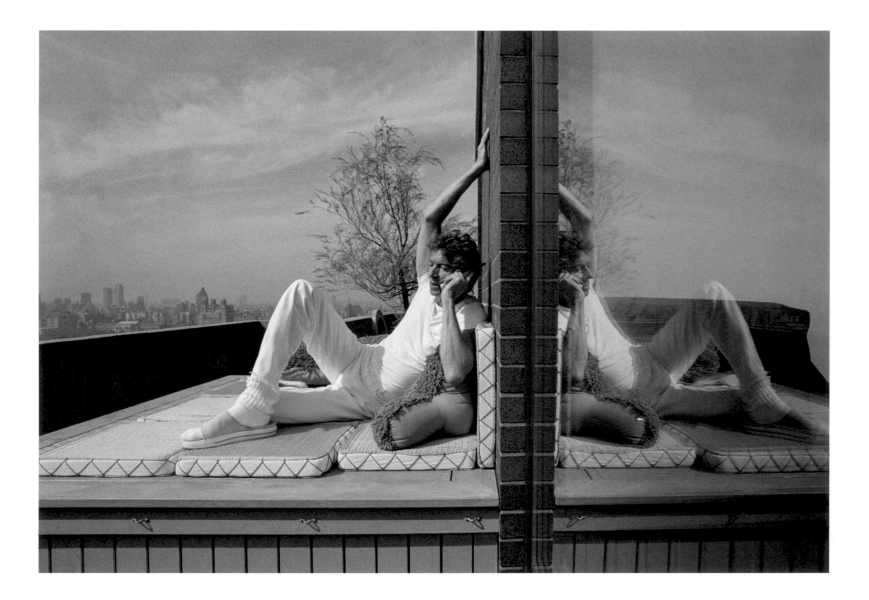

Tommy Tune, ten time Tony-winning performer and National Medal of Arts winner
New York, NY

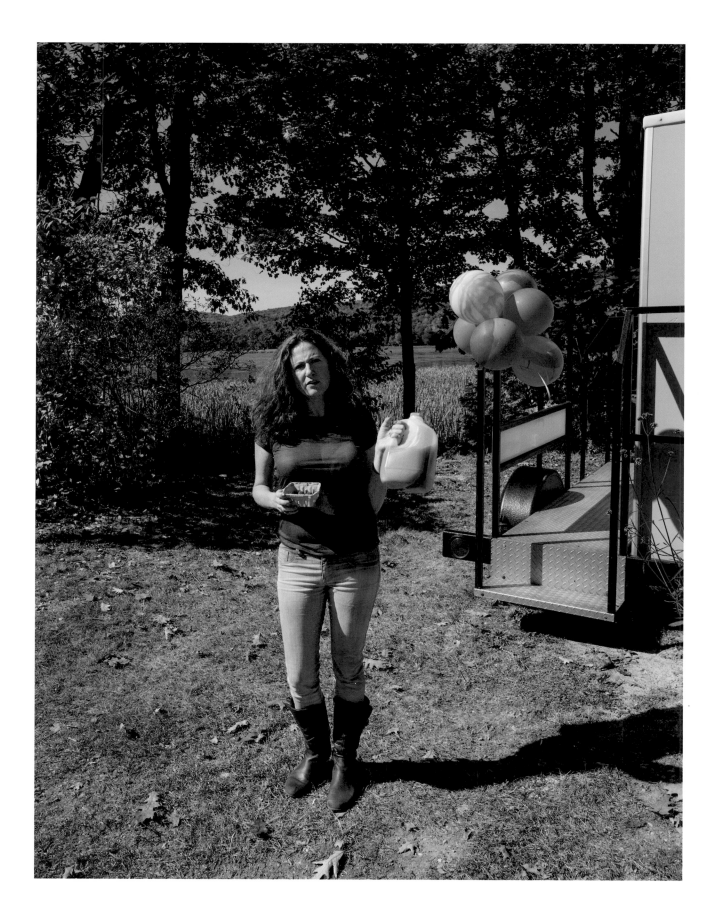

Neda Ulaby, NPR arts correspondent
In her yard on the morning of her wedding
Hubbardton, VT

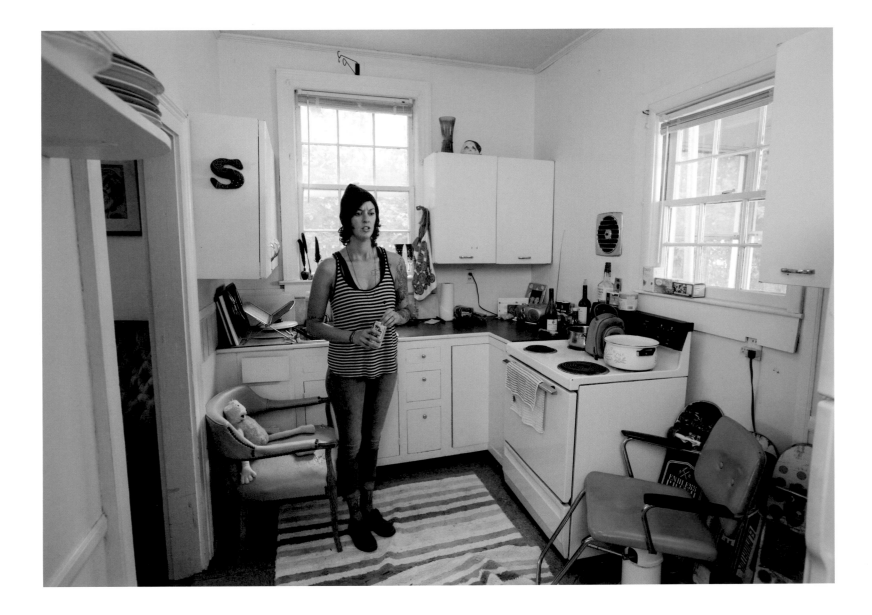

Rhea Reeves, barista

Raleigh, NC

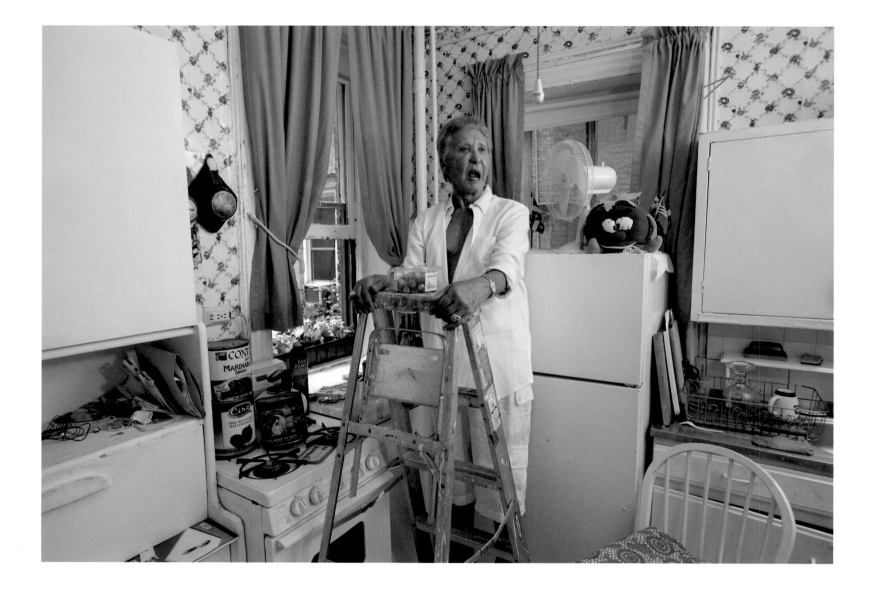

Tish Touchette, retiree
New York, NY

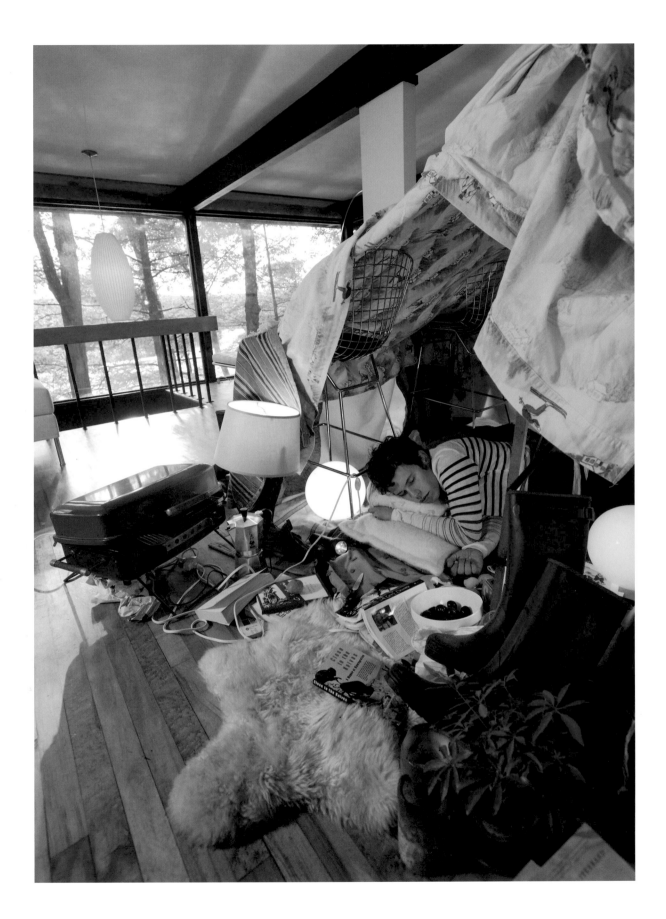

Anthony Goicolea, artist
Putnam Valley, NY

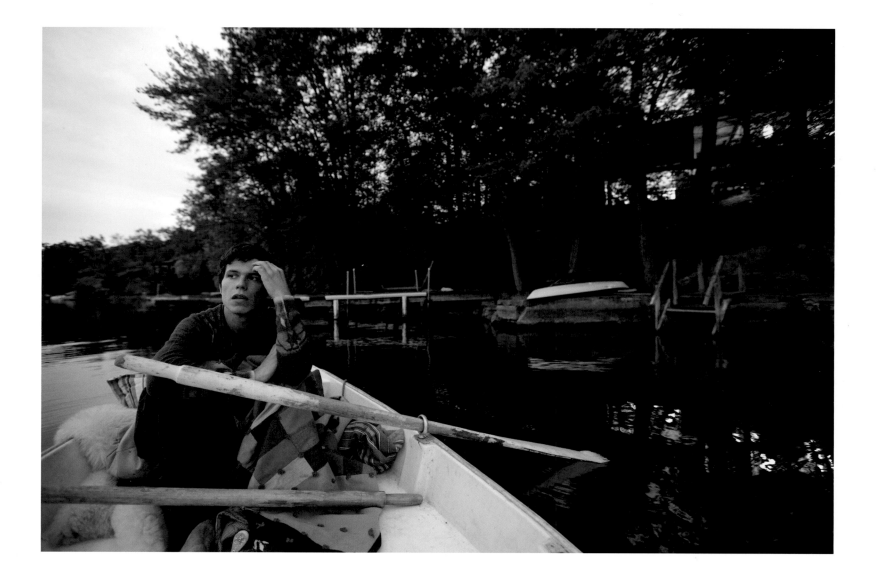

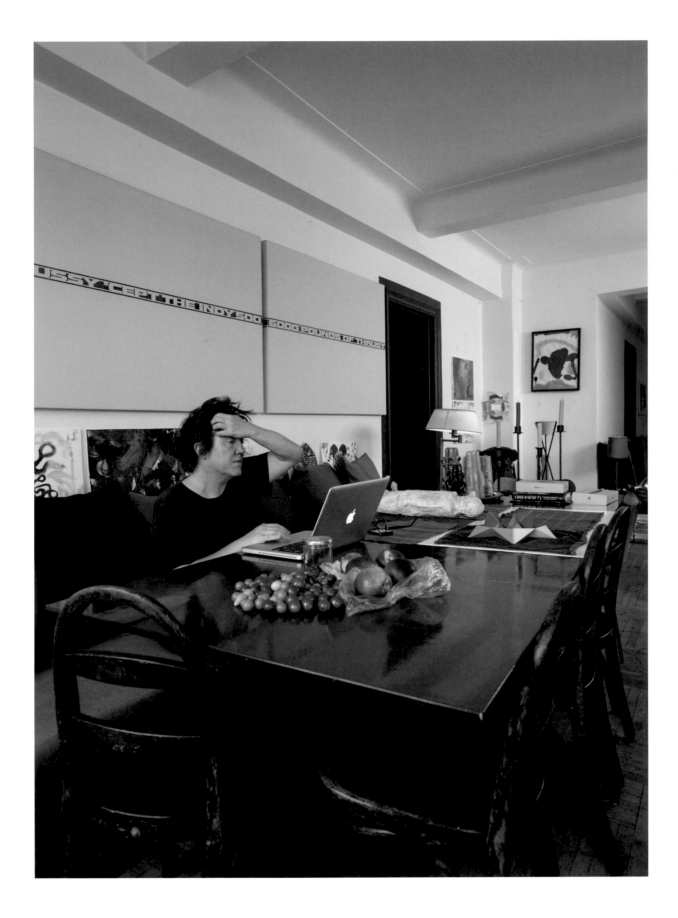

Christine Vachon, producer of *Still Alice*, *Boys Don't Cry*, *Far From Heaven*
New York, NY

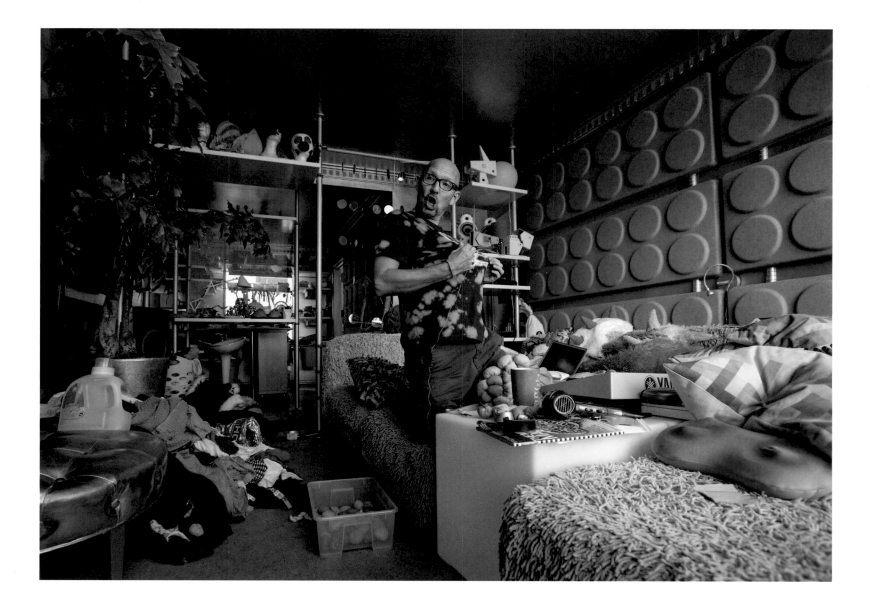

David Rajter, television producer
Constructing costumes for Burning Man
West Hollywood, CA

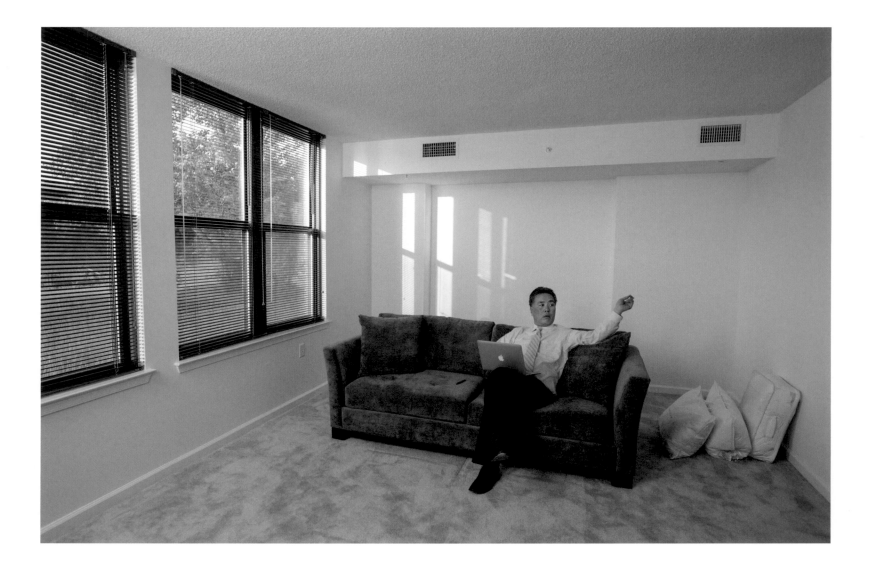

Mark Takano, US Congressman
Shortly after taking office
Washington, D.C.

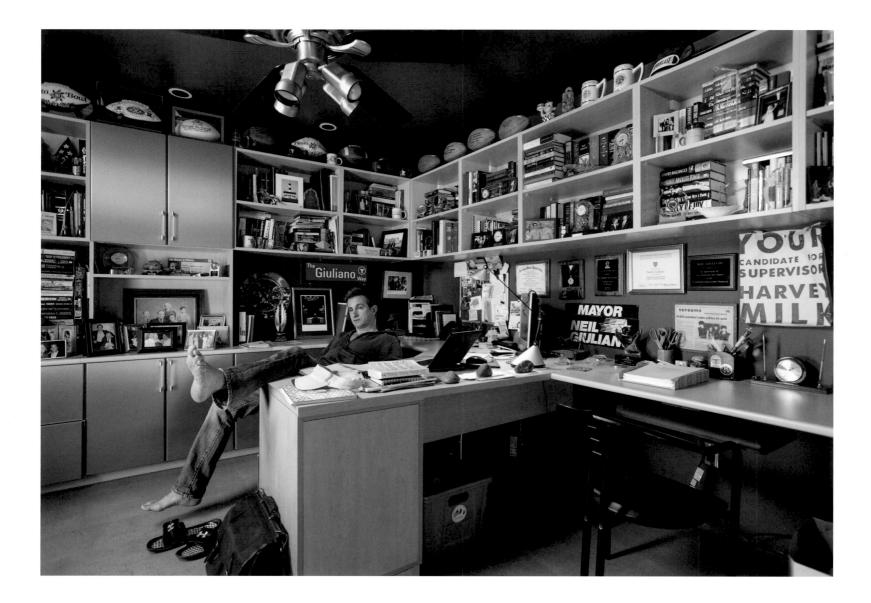

Neil Giuliano, former Tempe Mayor and president of GLAAD
Phoenix, AZ

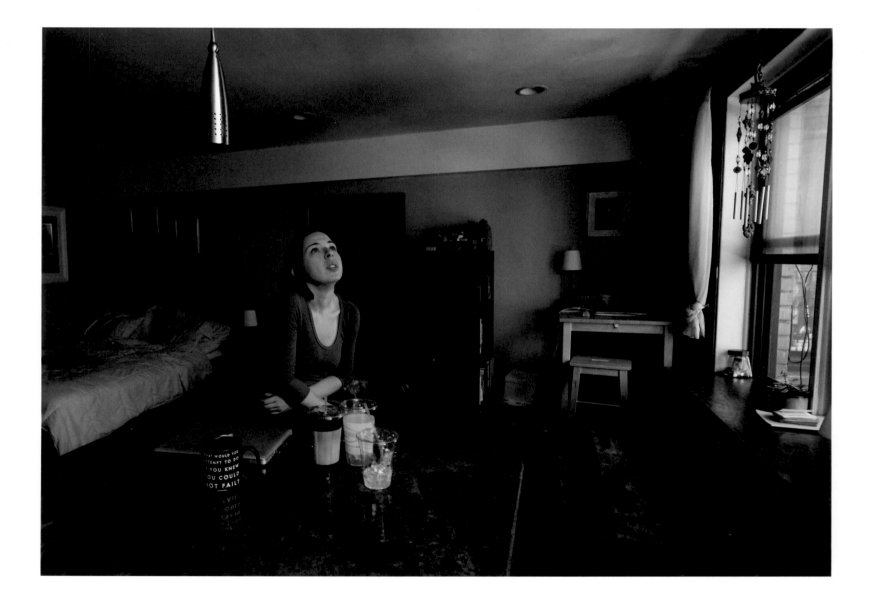

Heather Matarazzo, actress from *The Princess Diaries*, *Sisters*, *ER*, *Strangers with Candy*
New York, NY

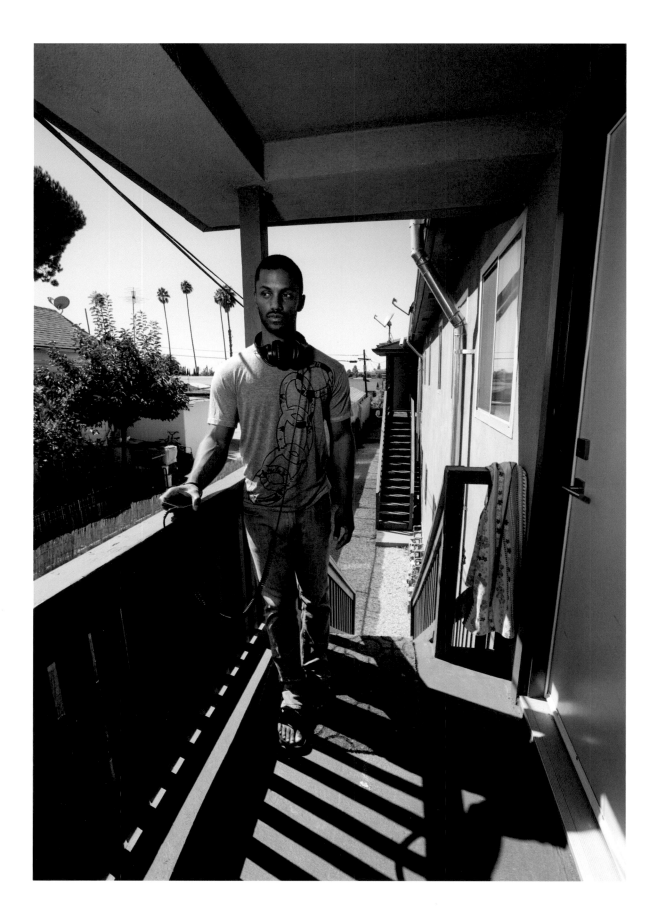

Darryl Stephens, actor from *Undressed*, *Noah's Arc*, *Desperate Housewives*
Los Angeles, CA

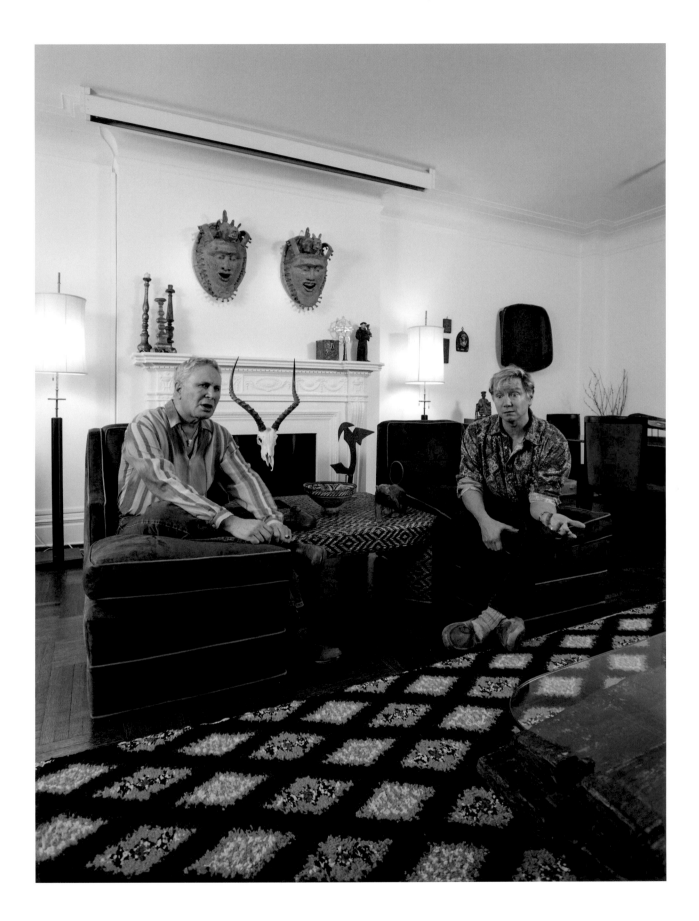

John Corigliano, Grammy and Pulitzer-winning composer
Mark Adamo, acclaimed composer
New York, NY

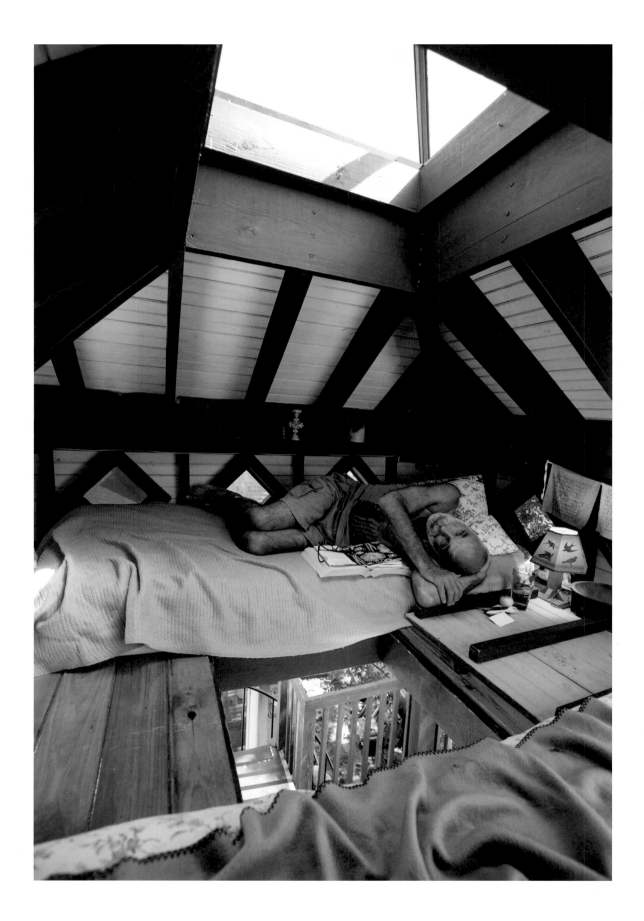

Ted Haykal, artist
In his back yard fort
Pikes Island, ME

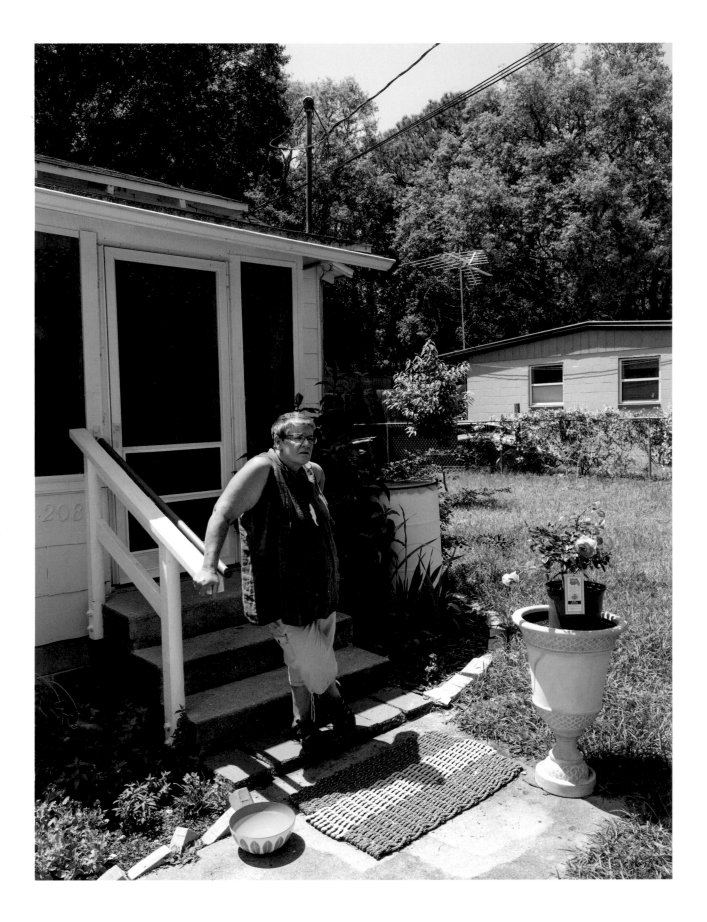

Linda Anderson, administrative assistant
Saint Augustine, FL

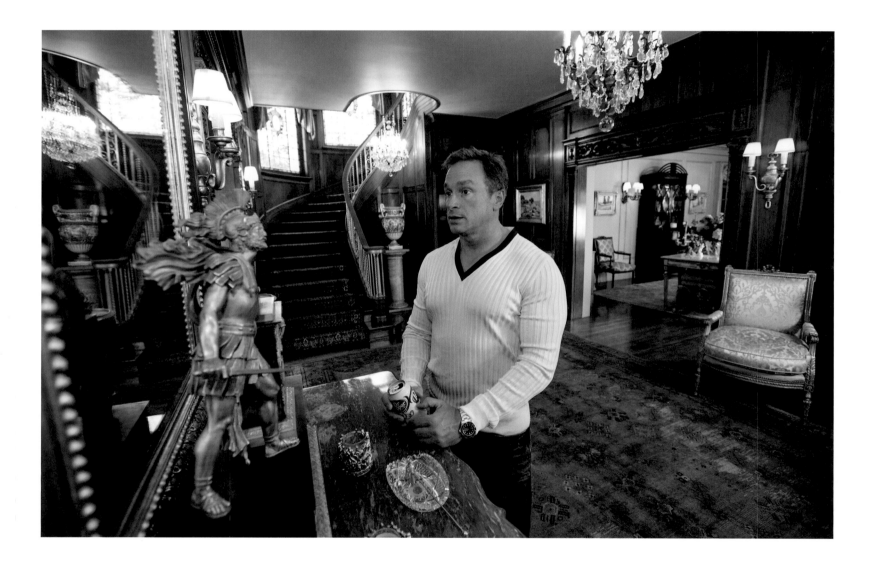

Wes Walraven, investment banker
Los Angeles, CA

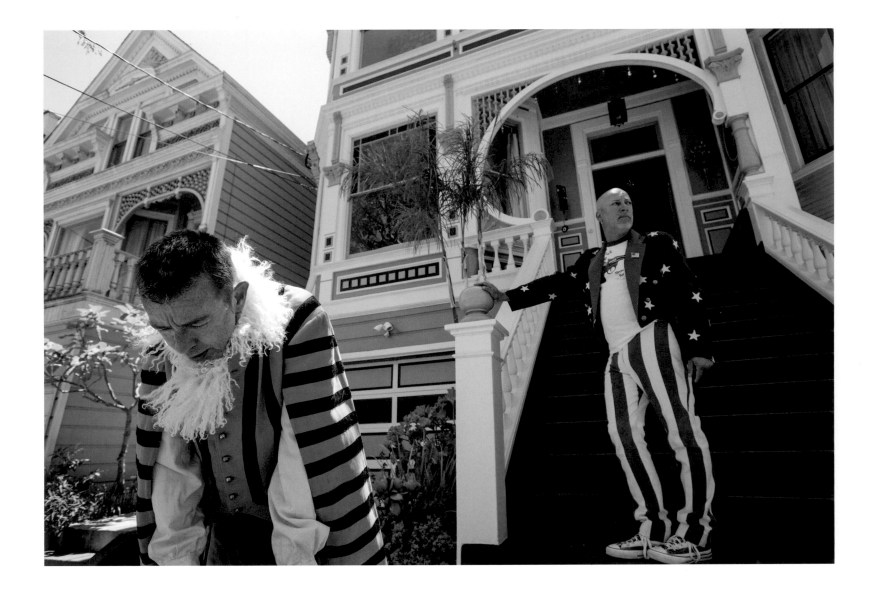

Mark Garrett, picture framer

Eric Smith, sock manufacturer

San Francisco, CA

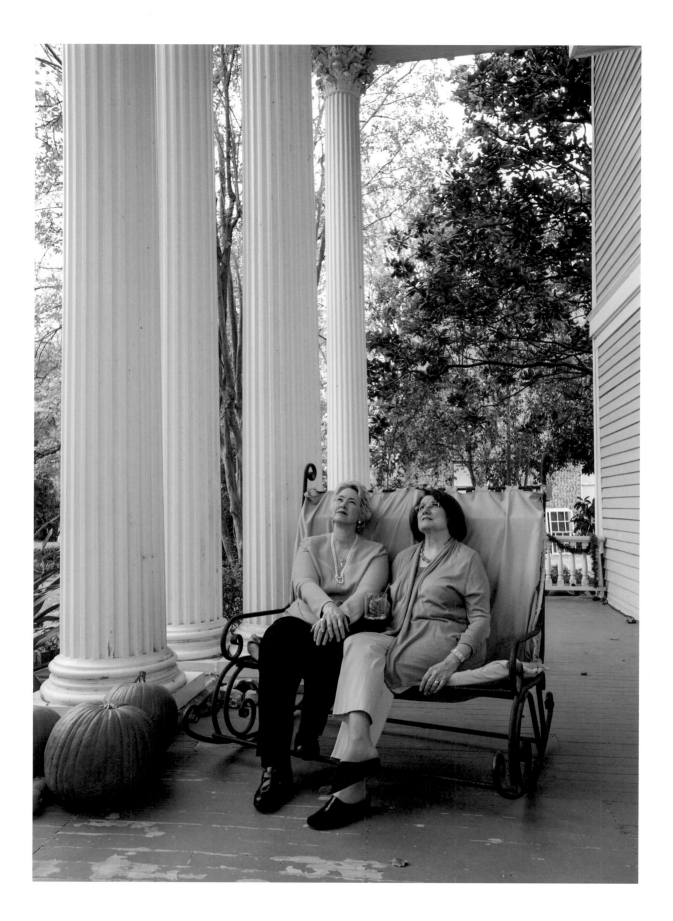

Annise Parker, Houston Mayor
Kathy Hubbard, bookkeeper
Houston, TX

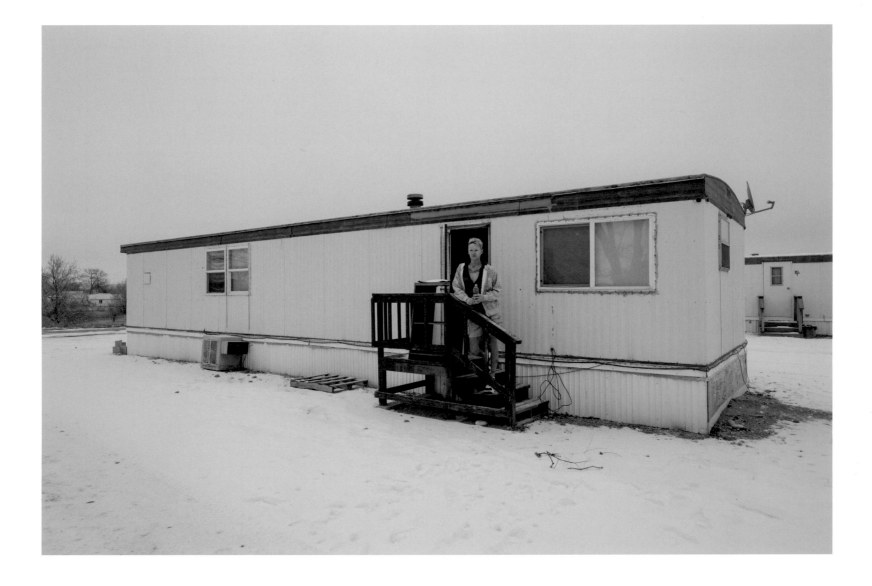

Cortnee Ponton, bartender
Myton, UT

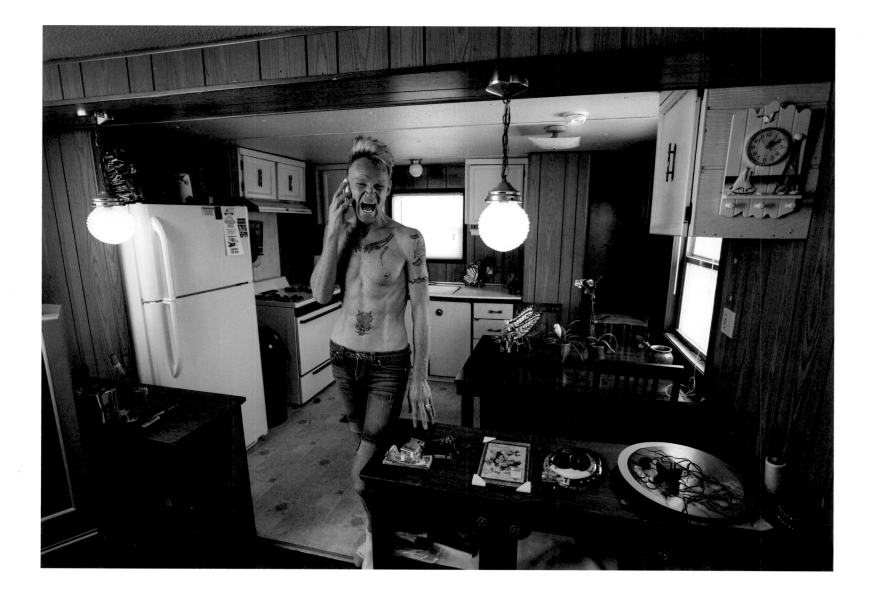

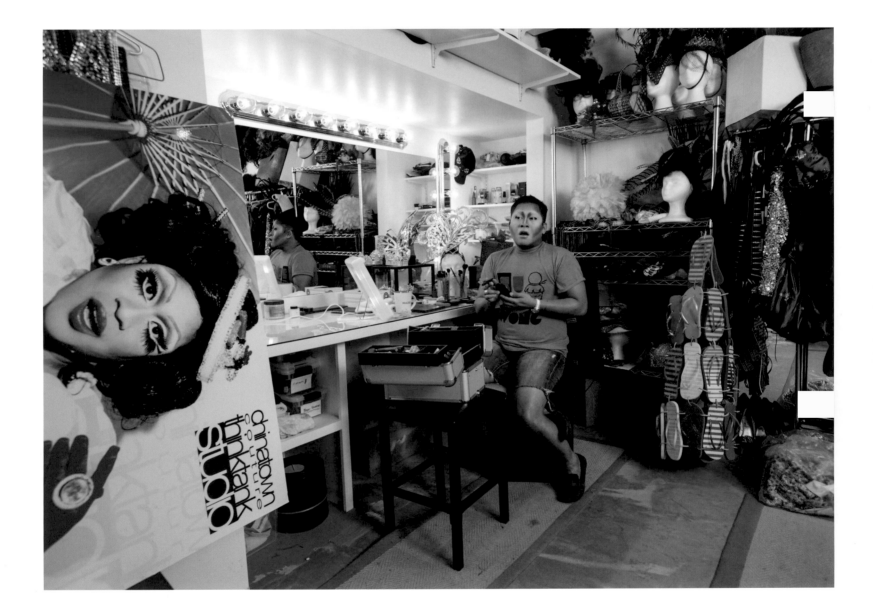

Arnold Myint, drag performer and chef from *Top Chef*
Nashville, TN

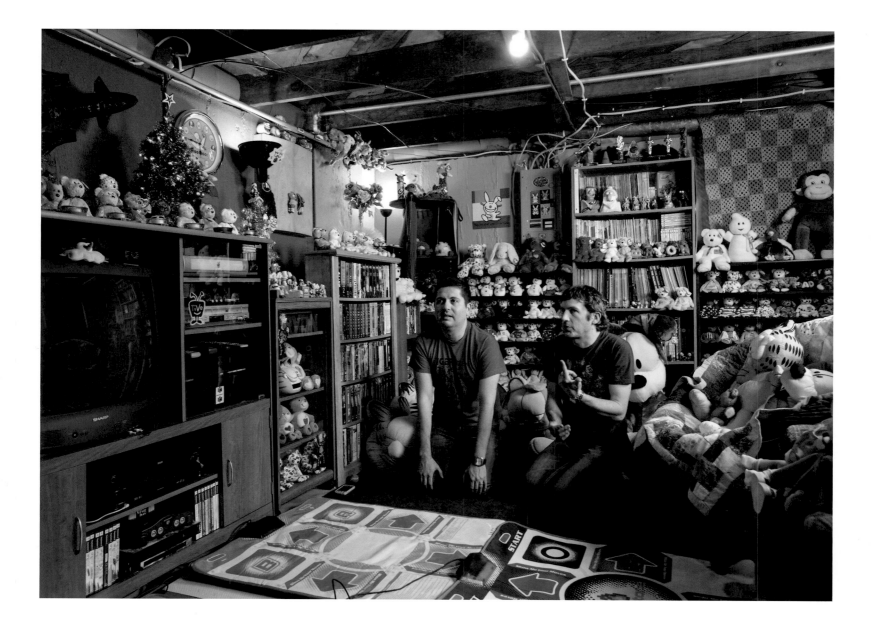

Oscar Reynaga, Latin American studies professor
Bryon Owen, elementary school teacher
Ottumwa, IA

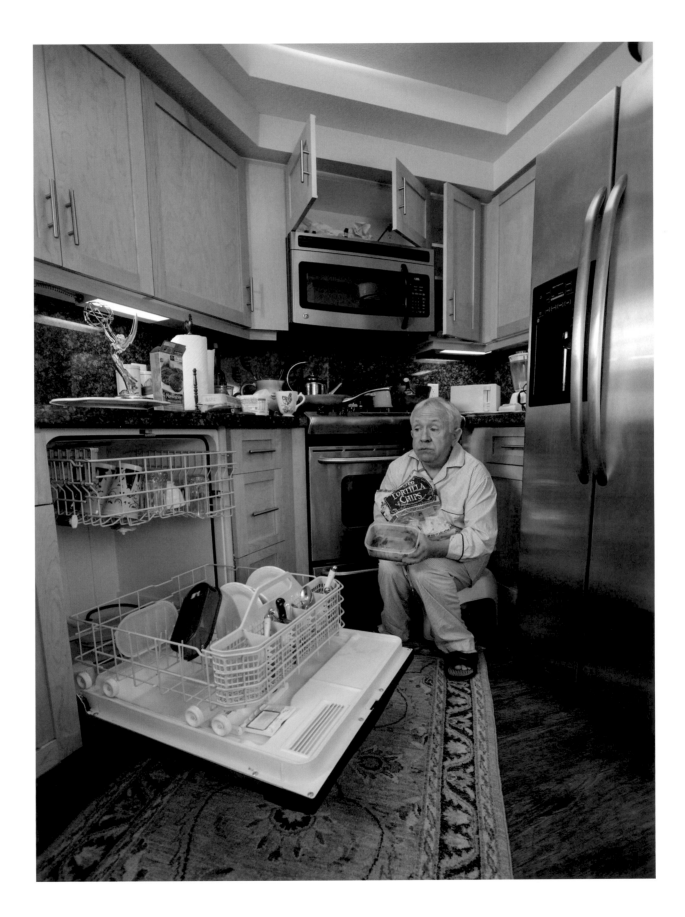

Leslie Jordan, actor from *The Help*, *Sordid Lives*, *Will & Grace*, *Boston Legal*, *Newhart*
Los Angeles, CA

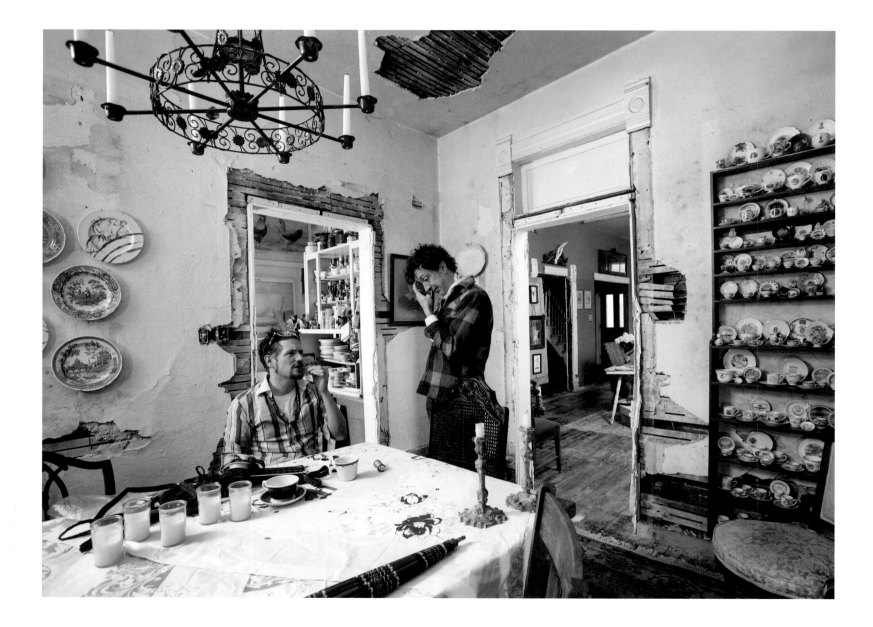

Jon Fulton Adams, fashion designer
Ron Megee, bon vivant
Kansas City, MO

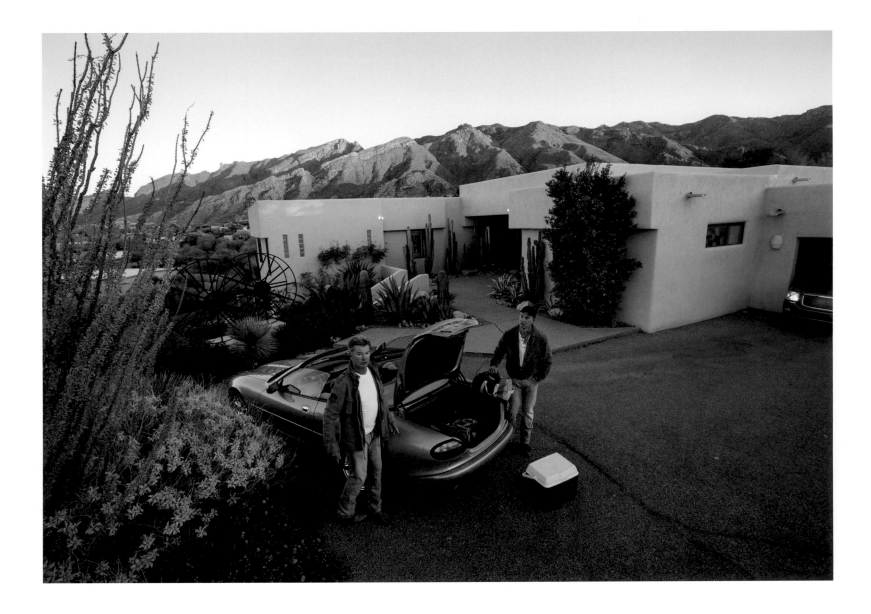

John Fikkan, airline design professional
Thom Sherwood, graphic designer
Tucson, AZ

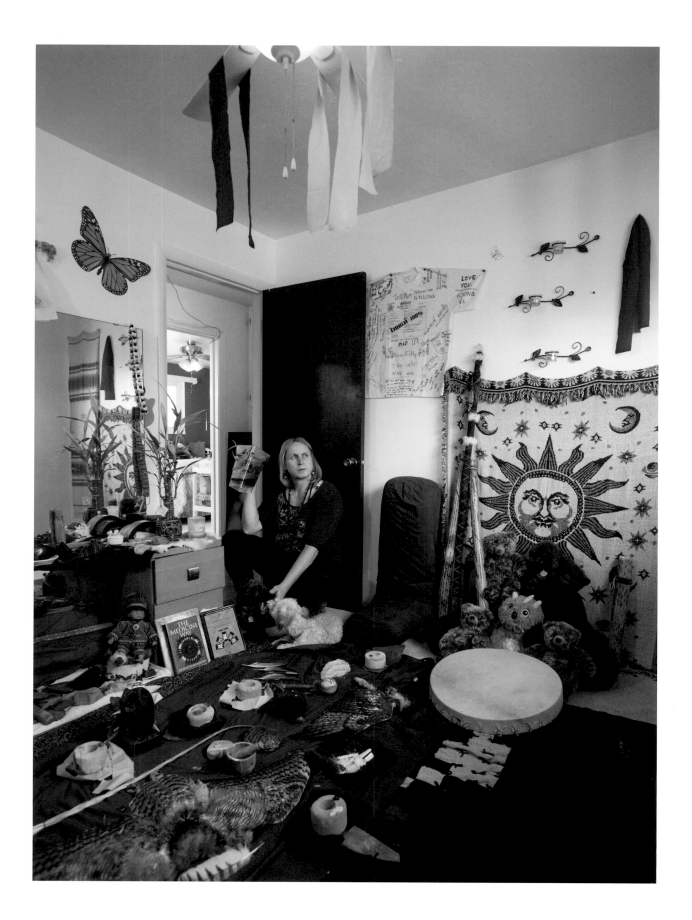

Dominique Storni, transgender Native American activist
In front of her shrine
Valley City, UT

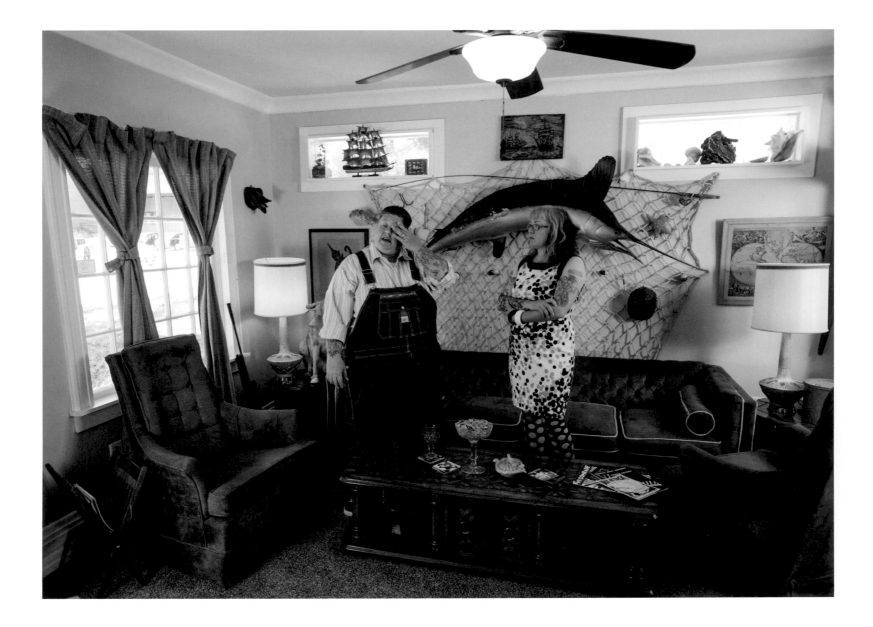

Ria Pell, chef from *Top Chef* and winner of *Chopped*
Kiki Carr, web developer
Atlanta, GA

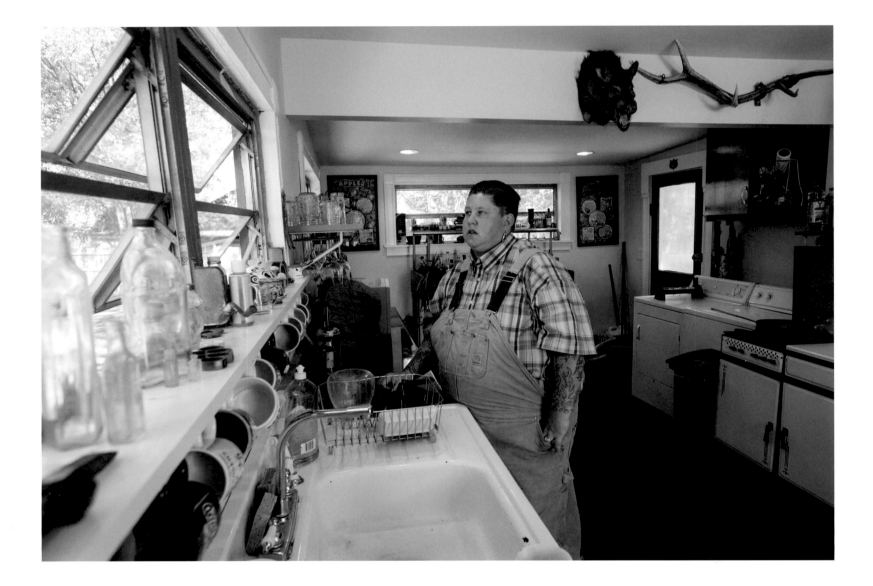

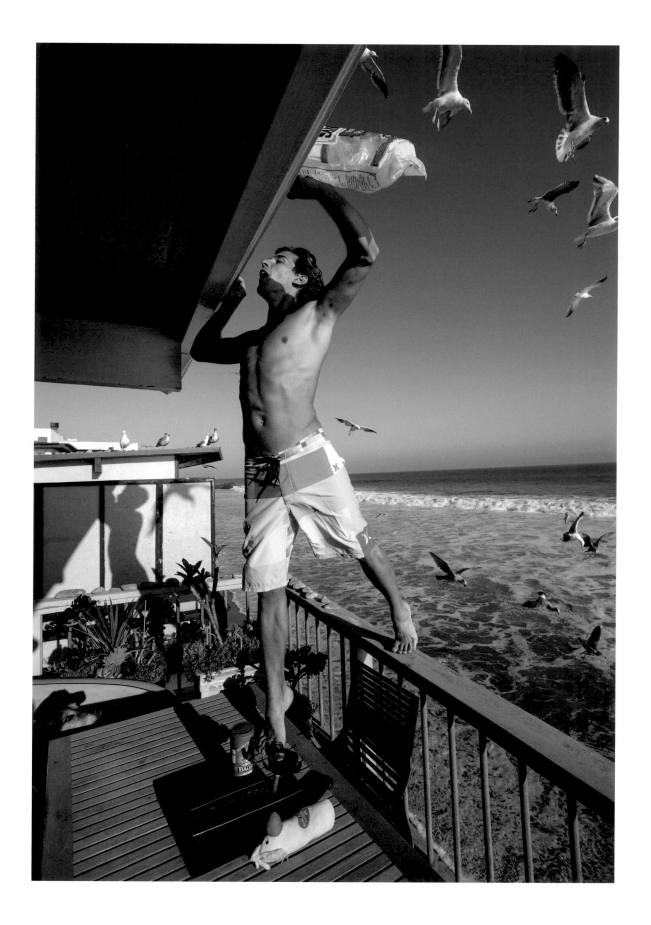

Madison Hildebrand, star of *Million Dollar Listing*
Malibu, CA

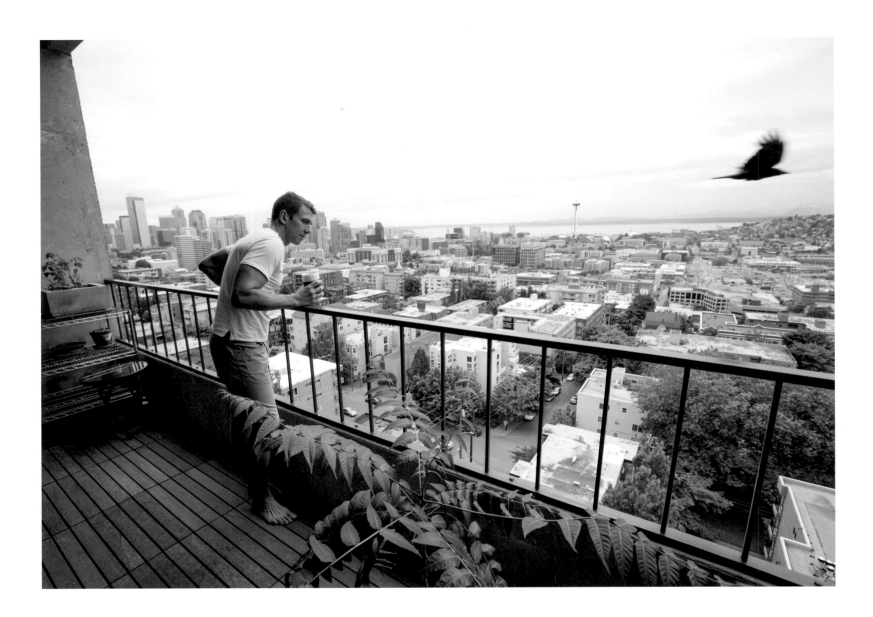

Jim Burkman, anesthesiologist

Seattle, WA

ACKNOWLEDGMENTS

I've been amazed by the kindness and generosity of others who have helped bring this series to fruition.

Many thanks for financial help from the following Sponsors: John B. Kennedy, Jason Hartrich, Neil Giuliano, Rebecca Thomas, Bruce Atwood, Margie Harris, John Fikkan and Thom Sherwood. As well as the following Donors: Erik Kon, Douglas Nielsen and Robert Browne. And the following Supporters: Kim Howland, Erlend Kjellstad, Jennifer Zary, Gregory Sarris, Earnest Watts, Mark Haukohl, Derrick Daubert, Christophe Le Gorju, Dale Harding and John Squatritto.

Special thanks to my partner, Dr. Lawrence Siegel and all of my family.

Thanks to those who helped with editing, design and production, especially Andrea Albertini, Eleonora Pasqui, Lorenzo Tugnoli, Amy Wilkins, Robin Brunelle and Geraldine Lucid.

Additional thanks to Tom Healy, Lynn Saville, Chris Boot, Brian Clamp, Yossi Milo, Gail Albert Halaban, Miriam Leuchter, Catherine Opie, Missy and Burt Finger, Matthew Pillsbury, Jess Dugan, Frank Evers, Holly Hughes, Susan Meiselas, Simen Johan, Jeff Dunas, Vince Aletti, David Maupin, Stephen Cohen, Cat Corman, Ed Robinson, Katrin Eismann, Kristin Hjellegjerde, George Pitts, Stephen Perloff, Johnnie Moore, Ashton Hawkins, Kathleen Clark, Harvey Stein, Terry Etherton, Peter Galassi, Eva Respini, Curtice Taylor, Susan Baraz, Hossein Farmani, Sherrie Berger, Bill Arning, Gary Tinterow, Clinton Cargill, Catheryn Johnson, Patrick McMullan, Jennie Dunham, Joanna Hurley, Linda and Lothar Troeller, David Fahey, Allen Thomas Jr., Jenn Karson, David Mehnert, Armistead Maupin, Larry Kramer, Thomas Lanigan Schmidt, David Del Tredici, Walter Burr, Junior Vasquez, Edward Albee, Todd Oldham, Bill Sofield, Chad Griffin, Elizabeth Birch, Congressman Sean Patrick Maloney, Randy Florke, Jann Wenner, Florent Morellet, Jonathan Capehart, Raphael Kadushin, David Groff, Andy Towle, Lily Tomlin, David Furnish, Leta Ming, Jane Lynch, Kathy Griffin, David Sedaris, Edmund White, Michael Cunningham, Andrew Solomon, Alexandra Hedison, Hunt Slonem, Bob Paris, Marc Selwyn, Kevin West, Tim Anderson, Greg Pierce, Tom Parry, Juan Bastos, Peter Gadol, David Codell, Tom Watson, Andrew Klayman, Ralph Wedgwood, Iarla Kilbane-Dawe, Peter Vissers, Alexander Gardner, Henrik Harpsoe, the Willmotts, Gyan Samara, Michael Crook, Zeren Badar, Madelyn Postman, Molly Waldstein, Rebecca Lowry, Simon Christmas, Sarah Fitzharding, Donald Lee, Stav Birnbaum, Da Ping Luo, Robert Bookman, Fred Specktor, Madeleine Brand, Eric Kranzler, Andrew Jones, Paul Bridgewater, Bob Kasunic, Norbert Beatty, Jeff Wolk, Chris Shirley, Charles Kaiser, Jonathan Rotenberg, John Crocker, David Rosen, Jim Sherman, Brian Offutt, Jesus Escobar, Andy Camp, Brian Ellner and Kevin Jennings.

Gratitude to subjects who were photographed but for whom space could not be found in the book, including Lexi and Kim Stolz, Greg Gorman, Michael Epstein, Scott Schwimer, Dave Koz, Dan Jinks, Chad Allen, Allison Shockley, Suellen Parker, Brian Graden, David Gold, Howard Bragman, Dale Levitski, David Cooley, Paris Barclay, Ross Mathews, Todd Schiffman, Guillermo Diaz, Jenny Factor, John Rabe, Oliver Furth, Tracy Baim, Tyce Diorio, ANT, Wilson Cruz, David Steward, Hal Bromm, Alfrado Paredes, John Hunter, Tobias Schneebaum, Robert Brown, J. D. McClatchy and Andy Tobias.

Finally, thanks to those interested in being photographed but for whom scheduling didn't work out, including Mickalene Thomas, David LaChapelle, John Dugdale, Chely Wright, Bill T. Jones, Congressman Jared Polis, Margaret Cho, Chaz Bono, Maurice Jamal, Carole Pope, Lee Daniels, Maulik Pancholy, Robbie Rogers, John Amaechi, Ilene Chaiken, Marc Cherry, Rip Taylor, Adam Shankman, Gus Van Sant, Reichen Lehmkuhl, Bryan Batt, Christopher Ciccone, John Barrowman and Sophie B. Hawkins.

BIOGRAPHY

Tom Atwood's recent work has focused on portraits of people at home. He has shot over 100 luminaries including Hilary Swank, Julie Newmar, Buzz Aldrin, Don Lemon, Meredith Baxter, George Takei, Alison Bechdel, Alan Cumming, Edward Albee, Andrew Solomon, Todd Oldham, Edmund White, Ned Rorem, Michael Cunningham and Ross Bleckner.

Atwood won Photographer of the Year from London's Worldwide Photography Gala Awards, as well as first place in Portraiture, chosen from over 3,000 entries from about 50 countries. He also won first place in Portraiture in the Prix de la Photographie Paris competition, chosen from thousands of entries from over 85 countries.

He has won over 30 additional awards including from the Griffin Museum of Photography, Center for Fine Art Photography, International Photography Awards, Image International, Santa Fe Center for Photography, Manhattan Arts International, World in Focus, Artrom Gallery Guild (Rome), Kodak, Fence at Photoville, *CameraArts Magazine*, *Photo Life Magazine*, *PDN*, *Photographer's Forum Magazine*, *Photo Review*, *Applied Arts*, *Communication Arts*, *Graphis*, American Photography Annual, One Life, American Art Awards, Photography Masters Cup, One Eyeland, Jacob Riis Award, IPOTY, Camera Club of NY, International Color Awards, Moscow International Foto Awards and APA.

Atwood's work has exhibited at the Museum of Photographic Arts, George Eastman Museum, Griffin Museum of Photography, Center for Fine Art Photography, Círculo de Bellas Artes (Madrid), LA Center for Digital Art, Pacific Design Center and Directors Guild of America. His work has exhibited at various art fairs such as Photo LA, as well as at several galleries, most recently ClampArt in NY, Steven Kasher Gallery in NY, Louis Stern Fine Arts in LA, Farmani Gallery in LA and PDNB Gallery in Dallas.

His work has been featured in over 150 publications in over a dozen countries including *The New York Times*, *Los Angeles Times*, *San Francisco Chronicle*, *Washington Post*, *New Yorker*, *Los Angeles Magazine*, *Elle*, *Huffington Post*, *Harvard Magazine*, *Art Newspaper*, *Artforum*, *Art Ltd.*, *Applied Arts*, *Photo Life*, *Photo Selection*, *Photo Review*, *PDN* and *Popular Photography*. Atwood has also appeared on Sirius, CBS, Bravo, Telemundo and other networks.

He has shot photography for a variety of corporate clients, from Disney to BMW, Lexus and CAA, as well as editorial clients, from *The Wall Street Journal* to *Brandweek* and *Angeleno*.

Atwood has a Bachelors from Harvard University and a Masters from Cambridge University (England). He has lectured on photography at various organizations and universities including UCLA and the School of Visual Arts, has been a juror for London's Worldwide Photography Gala Awards and was a portfolio reviewer for *Popular Photography* and *American Photo*. In a past life, he also served as a Director at several global advertising agencies including Ogilvy & Mather, McCann and DDB. Based in New York, Atwood has lived in Los Angeles, San Francisco, Boston, Amsterdam and Paris. He grew up on a dirt road in the woods of Vermont. Learn more and view dozens of additional photographs at www.TomAtwood.com.

Kings & Queens in Their Castles
Tom Atwood

Published by Damiani srl
www.damianieditore.com
info@damianieditore.com

© 2017 Damiani
All photographs © Tom Atwood

Front cover: Gary Tisdale-Woods, community volunteer. Greensboro, GA
Back cover: Mary Celley and Sue Williams, beekeepers. Brooklyn, WI

Color separations, printing, and binding by Grafiche Damiani–Faenza Group SpA, Italy

ISBN 978-88-6208-516-8